GHOSTS *of* GALVESTON

KATHLEEN SHANAHAN MACA

Haunted America

Published by Haunted America
A Division of The History Press
Charleston, SC
www.historypress.net

Copyright © 2016 by Kathleen Shanahan Maca
All rights reserved

Front cover: The historic Hotel Galvez, known as the "Queen of the Gulf," has kept watch over the waters of Galveston since 1911. Its staff, as well as its ghosts, welcome visitors from all over the world.

First published 2016

Manufactured in the United States

ISBN 978.1.46711.965.8

Library of Congress Control Number: 2016938316

My endless love and thanks to my husband, John, and my daughter, Kelsey, for their support and patience during the months I spent focusing on spooky stuff—more than usual.

CONTENTS

ACKNOWLEDGEMENTS

I would like to thank all of the Galvestonians who shared their stories and photos with me for this project, including Trish Clason, Boyce Pryor, Jan Johnson, Terry Ritter and Cheryl Jenkines.

Thanks also to Christen Thompson and Julia Turner of The History Press, who were a delight to work with during the process of creating this book.

I am especially grateful for the help of Peggy Dillard, Sean McConnell and Travis Bible from the Galveston and Texas History Center of the Rosenberg Library for their help in locating photos to bring the stories to life.

INTRODUCTION

Galveston Island welcomes over seven million visitors a year, most of whom are drawn to its relaxing beaches, history, shopping and wide variety of cultural entertainments, including one of the largest concentrations of Victorian architecture in the country.

The island also ranks among America's most haunted destinations, and just about anyone you meet on the island has a ghost story or experience to share.

Before the city was chartered in 1839, the island had already been home to the Karankawa Indians, Spanish and French explorers and countless seafarers, including the infamous pirate Jean Lafitte. In the years that followed, the port city thrived, becoming so prosperous that the mansions of millionaires lined Broadway.

Then a series of tragic events occurred, including the Civil War and repeated yellow fever epidemics. Even so, Galveston grew to become the largest city in Texas in the 1870s and 1880s.

Hurricanes also pounded the coastal city, the worst of which was the Great Storm that struck on September 8, 1900. Killing an estimated six to eight thousand people and obliterating two-thirds of the island's homes and businesses, it remains the worst natural disaster in the history of the United States.

Drastic measures had to be taken to handle the number of corpses that covered the island. Many bodies were buried where they were found, which means that almost any portion of ground walked on today might be a grave.

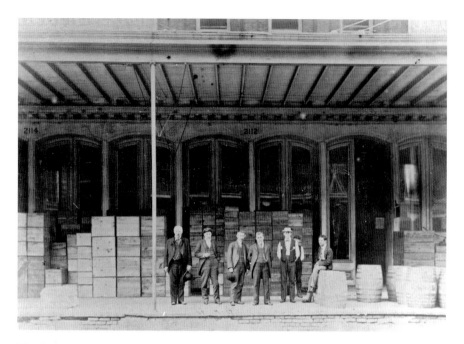

Merchants in front of the Produce Building, now home of the Old Strand Emporium. *Courtesy of the Rosenberg Library, Galveston, Texas.*

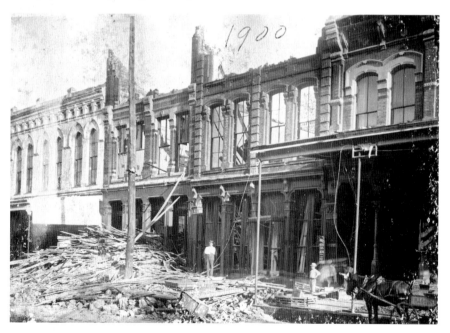

Damage at Ritter's Saloon on the Strand, where the first storm victims died. *Courtesy of the Rosenberg Library, Galveston, Texas.*

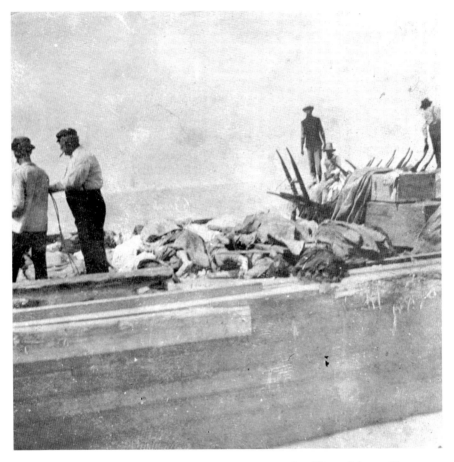

Storm victims being loaded onto barges. *Courtesy of the Rosenberg Library, Galveston, Texas.*

In the days that followed the storm, men who were drafted into Dead Gangs loaded the bodies into carts and carried them to the Strand to be stacked in temporary morgues. The men who ran the death houses were issued a bottle of whiskey and told to stay with the bodies until they were identified.

Those who remained unclaimed were loaded onto barges, which took the departed out to sea. Just a few days later, however, they washed back ashore, and the situation became desperate.

As a last resort, funeral pyres were lighted across the city. Photos still exist of this process, including one directly in front of the Bishop's Palace.

Impossible as it seems, Galvestonians recovered and went on with their lives, but they never forgot.

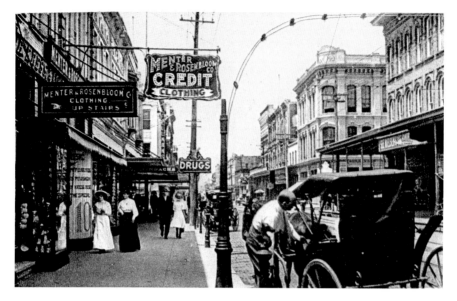

The bustling Galveston business district, 1910. *Author's collection.*

People say that spirits can draw strength from water. If that is so, it explains why an island, surrounded by water, is home to so many ghosts. The dead outnumber the living on this island, and many insist on remaining. They've always been here and perhaps always will be. Newspaper accounts from the 1860s even describe the ghost of a woman in white that wandered to the piers each night.

The tales of ghosts on the island are too numerous to gather in one book, so I've conjured a few of my favorites and some new discoveries to share with you here. I hope you enjoy the stories and perhaps visit a location or two to see if you can experience anything yourself.

Do the ghosts of Galveston really exist? Decide for yourself.

1
HUTCHINGS SEALY BUILDING

2326–28 STRAND

The preeminent nineteenth-century architect Nicholas Clayton designed this pair of three-story buildings to appear as if they are one. The narrow Ball, Hutchings and Company bank building on the corner and the John Sealy office building next door are an impressive sign of the wealth that was once part of the Wall Street of the South.

Built in 1895 of gray and pink granites, red Texas sandstone and buff-colored terra cotta, they were restored to their former grandeur in 1985. A shield on the west façade is emblazoned with the 1895 erection date, and the firm's founding year of 1854 appears below it.

Looking through the glass doors on the Strand side, visitors can see an ornate wrought-iron and slate staircase ascending toward a skylight between the two buildings. It is on this staircase that the woman in white is often seen, although she has appeared in many parts of the two buildings. She is the ghost of a heroic schoolteacher whom locals have named Sara because her true identity has been lost.

During the 1900 hurricane, Sara and others took shelter in these massive buildings. As the storm surge rose along the Strand to seventeen feet, the people climbed to the top floors. Witnesses from the disaster relate the story that the brave teacher selflessly climbed through a window, balanced on the ledge and grabbed people as they floated by in the floodwaters, pulling them inside. Those victims who were already dead were put on one side of the room, and the living were laid on the other. She stayed in the building for several days caring for the sick and

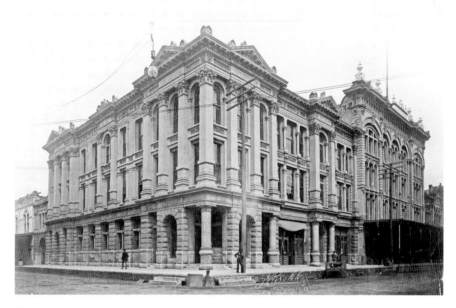

The Hutchings Sealy Building, designed by Nicholas Clayton. *Courtesy of the Rosenberg Library, Galveston, Texas.*

injured until she herself succumbed to the disease epidemic that followed the storm.

Nothing much is on the third floor of the buildings now except for retail warehouse space. Even so, certain employees refuse to go there because they feel they are being watched. The whispering sounds on the stairs contribute to their uneasiness.

A visit to the second-floor restroom used by employees and customers can occasionally be unsettling, as stall doors have been seen and felt to shake and pound violently. Heavy footsteps have been heard walking and running on the hard floors near the area, as well.

The retail space on the first floor of the Sealy building is currently home to a charming boutique called Tina's on the Strand. Ladies who work there often need to pick up after the visits of a ghost who's a bit of a rascal.

The workers at Tina's have a routine of thoroughly cleaning and locking up their space at night, but they often come in the next morning to find surprises. They feel the spirit is a little boy who is just looking for attention, not truly meaning any harm.

One morning, a candle, which had been sitting on a shelf several feet away, was found squarely in the middle of the floor. It would have

been impossible for the ladies to vacuum around it without seeing it the night before.

When the shop has opened on other days, a variety of unexpected sights has greeted the employees: a stack of *Galveston Monthly* magazines they keep to give to customers strewn across the floor, a plate that had been sitting on the back of a display rack broken on the floor even though the items in front of it were undisturbed and a blouse that had been buttoned from top to bottom lying on the floor while its hanger remained on the rack.

The boy is also most likely responsible for the tiny handprints at the bottom of the outside of the glass elevator on chilly days when the glass fogs. What's interesting about this is that the outside of the glass is encased with another layer of glass and unreachable by human hands.

The little one probably isn't alone; the aroma of pipe tobacco is often detected in the vicinity.

Next door at the jewelry shop, the owner tells about one night when a necklace and its entire display stand went missing. The disappearance was discovered just before closing, and the staff searched thoroughly for it, with no success. When they opened the store the next day, the stand with the

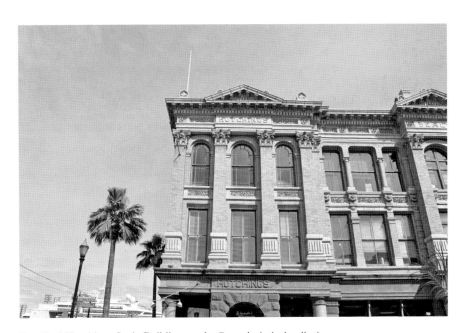

Detail of Hutchings Sealy Building on the Strand. *Author's collection.*

15

necklace was sitting directly on the counter in plain sight. Every employee who was asked denied having found it and swore that the counter was empty when they had closed the night before.

Workers in the building attest that the spirits don't make them fearful for the most part. They think of them as part of their community.

2

HENDLEY ROW

2010 STRAND

Hendley & Company Cotton Factors was one of the largest business houses in Texas in the 1850s. The series of four separate buildings known as Hendley Row was constructed with a shared three-story brick façade between 1855 and 1858. Ornamented with grand granite columns and cornices, it made a statement of financial strength on the Strand.

Now utilized as inviting retail, office and loft spaces, Hendley Row features glass block centers on each floor, allowing natural light to fill the spaces.

Hendley Row is also the home of several generations of spirits.

The dangers inherent in working in bustling warehouses was as much a fact of life as the cruel reality that many children worked there, trying to help their families make a living. One spirit that haunts the Hendley is thought to be a remnant from that sad era.

The startling visage of a badly injured teenager appears just before something bad is about to happen. Wearing a blood-covered white shirt, bearing cuts on his face and missing an arm, the boy stumbles across the floor before disappearing. Taken as an omen, this is one ghost no one wants to see for him or herself.

The Hendley Row structure played a significant role in the Civil War's Battle of Galveston, on January 1, 1863.

A wooden cupola on the roof of Hendley Row, long since gone, served as a lookout post for the Confederacy. A group of self-designated men, known as the JOLO guards, kept watch there for approaching Union ships

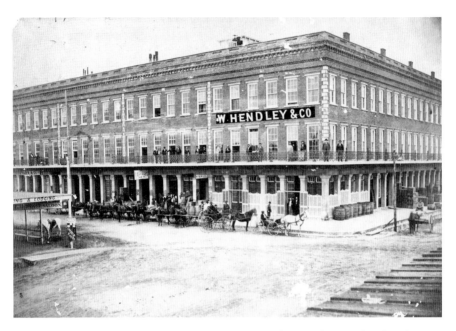

Hendley Market, with original wooden cupola on the roof, 1858. *Courtesy of the Rosenberg Library, Galveston, Texas.*

and socialized with visitors who thought of an impending battle more as entertainment than a danger.

As the battle began, the USS *Owasco* shot a cannonball at the building, leaving a scar that can still be seen today. The cornice on the seventh column on the Twentieth Street side of the building bears the damage.

A cannonball and piece of Hendley flooring imbedded with shrapnel can be viewed at the Rosenberg Library Museum, as well.

Because the Hendley was alternately used to headquarter Confederate and Union troops as control of the city changed hands, phantoms from both sides are seen wandering in front of and inside the building.

The most well known of these is a Confederate soldier wearing his gray uniform who can be seen running up and down the stairs and walking around the second floor through the windows at night.

The sounds of pacing back and forth across the roof can also be heard during early morning hours. It might be the echoes of the JOLO guards still on watch.

After the war, businesses moved back into the row and eventually restored normality to the district. But the worst tragedy ever seen by Galvestonians was yet to come, and the Strand would become ground zero of the aftermath.

There is no way to know whether a few of Hendley's occupants are apparitions of victims of the 1900 storm or of family left behind to fruitlessly search for their loved ones.

A lady in a white Victorian dress has often been seen ascending or descending the stairs at the back of the building. Some have also heard her softly crying or seen her desperately searching the streets surrounding the building.

Sounds of small feet running around the upstairs apartments are attributed to the ghost of a little boy, wet and disheveled, who can be seen wearing a gray winter suit, hat and boots. He has also been encountered sitting or leaning on the stairs and has even been photographed through a window.

The most pathetic of this group is a four- or five-year-old girl who sometimes plays near the skylights. Other children, whom she tells that she is lost and can't find her mother, most often see her. If the living children enlist the help of adults, she vanishes.

Mysterious dragging sounds across ceiling joists and sounds of footsteps in the attic have been heard and are said to last for hours. Once the space is investigated in the daylight, there is no evidence of objects having moved and no way in or out of the area.

As sad as some of the specters at the location are, the living tenants and residents of the building don't feel fearful and are almost protective of these pitiful souls.

3
MERCHANTS' MUTUAL INSURANCE BUILDING

2319 STRAND

Built in 1870, the Merchants' Mutual Insurance Company Building was constructed as an identical replacement to its original, which was lost in a fire in 1869. Inspired by French architecture, the mansard-style roof is said to have been the first of its kind on the island and makes it easily distinguishable from other buildings along the Strand.

Now the building is home to Galveston Old Time Photos, where visitors can have their photo taken in period clothes. Customers may need to double-check the images for someone who wasn't posing with their party.

The spirits of several men, one playful little girl and a family group roam the floors of the building, seemingly misplaced in time. As with most structures on the Strand, the unseen residents that call this building home are spirits that lost their way during the horrors of the 1900 storm.

At one time, the owners of the photography studio installed buzzers, so customers could alert employees at the rear of the building to their arrival. When the buzzer began to frequently ring out by itself, it was disconnected. That didn't stop it from sounding from time to time. Perhaps the little girl is finding fun in getting the attention of those around her.

Occasionally, items have flown off counters directly at workers with no apparent explanation.

One male entity that the tenants call Charlie sets himself apart, however, as one of the few malevolent ghosts on the island. Thought to be a man who lost his life by unknown causes in the structure long ago, he angrily paces the attic establishing his territory.

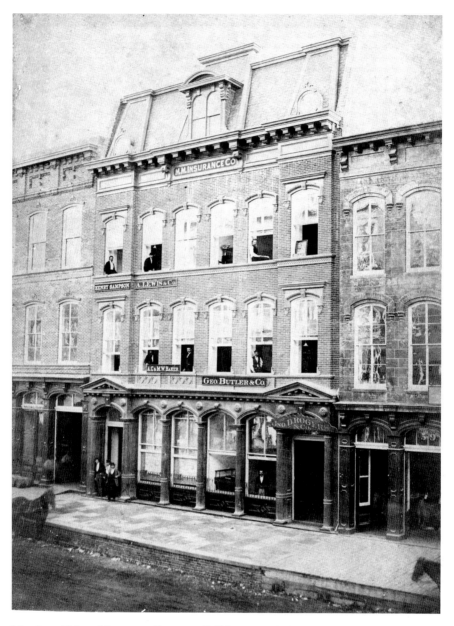

Merchants' Mutual Insurance Company Building, post–Civil War, with businessmen posing in window and doorways. *Courtesy of the Rosenberg Library, Galveston, Texas.*

The top floor, with soaring thirteen-foot-high ceilings, once contained water tanks to supply the water closets and washstands. Used for storage now, the space is virtually never entered by the owner or tenants unless absolutely necessary.

Visitors to the area report feeling the presence of evil and dread. Occasionally using force to make his existence known, the spirit will go so far as to push interlopers to insist that they leave his space.

Pets brought inside the lower-floor store space often appear to become uncomfortable and want to leave the premises. They obviously don't need as much encouragement as people.

4

BUTTEROWE BUILDING

2307–9 HARBORSIDE DRIVE

The easiest way to locate the 1885 Butterowe Building these days is to find the attractions housed on the ground floor: the Mayfield Manor and Pirates! Legends of the Gulf Coast.

Just behind Saegerfest Park, Mayfield Manor is a haunted house attraction featuring the fictional character of Dr. Horace Mayfield, who supervised the operation of one of the post-hurricane morgues in 1900 and went mad.

While the story is fictitious, the building itself did serve as one of the many temporary morgues after the Great Storm. The shrouded bodies were laid in rows on the floors of the building, waiting to be identified, until time and its effects on the departed demanded that they be removed.

Although the building originally housed a sail-making facility and furniture factory, the darkest chapter of its existence seems to have given it a new focus.

Despite the fact that all parts of the historic building share a macabre past, most of the paranormal activity in the building seems to take place on the haunted house side of the attraction. Scripted to use live actors, it often features ghostly interruptions that most visitors assume are just part of the act.

Mayfield's main spirit resident is a teenage boy they call Thomas. He likes to pull pranks on employees as well as visitors. He especially likes to play with the motion-sensor props like the air cannon, which is rigged to blow air unexpectedly as people walk through the attraction. One female employee was surprised to set it off one day because she knew it had been turned off. Not a fan of the prop, she reacted by yelling at Thomas to stop scaring her. After the cannon was checked and turned on, it ceased to work for the rest of the day whenever she was near it.

The massive iron storm shutters on the back of the Strand's Butterowe Building have offered protection from hurricanes for over a century. *Author's collection.*

The entity also shows a talent for mimicking voices, calling the names of employees in voices they recognize.

A psychic who investigated the property claims to have recorded shadows running around the pirate side of the exhibit as well.

Ben is another ghost on the site that tends to prefer more physical manifestations, including causing doors to open and close by themselves and locking people in or out of the bathrooms.

An elevator with a heavy door and solid latch closure has been known to open by itself. Once, it even began to violently shake, as if someone was unable to open the door. Luckily no one was inside at the time.

Backdoors to the sets allow actors to travel between the rooms without being seen by customers. With the sets' thin walls, they can simply listen to see if anyone is coming. If they hear a scene being performed, they can judge how much longer it will be before the group passes into the next room.

One of the ghosts, however, is so familiar with the script that he often recites it to confuse those waiting to change locations. The employees find out later that there was no one in the room they were waiting to enter. The security cameras can confirm it.

Customers at Mayfield might get more than they paid for, but after all, they are there for a good scare.

5

SPRINGER BUILDING

2119–23 STRAND

O riginally constructed as two separate buildings, the 1878 Clara Lang Building and the 1877 Marx and Kempner Building, this structure was remodeled into a single edifice after receiving extensive hurricane damage in the 1940s. The building at 2119 Strand originally had four floors, but it lost its top level to the 1915 hurricane.

An architectural trompe l'oiel mural by artist Richard Haas on the façade gives it the appearance of being much more ornate than it is in reality.

One of the earliest tenants of the building was Ratto and Company, which manufactured plain and fancy candies and chewing gums. That company was followed by the printer F.O. Milis and Company.

Oscar Springer, in whose honor the building was renamed, came to Galveston from Germany in 1902 and became the building's most famous tenant. After teaching piano and German for a short period of time, he began publishing a weekly German-language newspaper, *Die Galveston Post*. He later founded the Galveston Piano Company and eventually bought out his neighboring tenant, F.O. Milis, expanding into a printing business. All of these interests saw their heyday in the Clara Lang portion of the building.

The upper floors of the Springer are currently loft apartments with beautiful oak and pine floors, high ceilings and one resident ghost.

A teenage male entity that has been seen to wear knickers and knee socks, suspenders and a white shirt with the sleeves rolled up resides there. Although his clothing seems appropriate to the period of the 1900 storm, there is no

way to know for sure that his spirit remains from that event. He might just as easily have been employed by one of Springer's many enterprises and feel that the building is where he still belongs.

Often seen out of the corner of people's eyes or passing quickly through a hallway, the amiable spirit seems content to observe people and his surroundings without interacting with them. His presence is more often felt than seen.

He has also been spotted sitting on the rooftops of other buildings on the block, swinging his legs and watching passersby.

6

J.D. ROGERS AND E.B. NICHOLS BUILDINGS

2013–19 STRAND AND 2021–23 STRAND

Currently used as a venue for special events, such as weddings, fundraisers and banquets, the 1894 Rogers Building was strictly business in earlier times.

Directly across from the Hendley Building, it was used as a variety of mercantile establishments through the years, including a liquor wholesaler and stores selling goods arriving on ships at the nearby wharves.

Severely damaged in a fire in July 1900, it survived the disaster as well as the Great Storm two months later. The edifice, along with the adjoining Nichols Building, was completely renovated in the 1980s.

The building is easily distinguished by the twin parapets at the roofline, which still bear the initials JDR and the year 1894.

Though many of the structures along the Strand served as temporary morgues after the Great Storm, experts agree that the Rogers Building is the site where the most famous post-storm morgue photo was taken.

A number of phantoms have been spotted standing and floating across the balcony gazing down as people pass by.

Tenants as well as visitors have seen the ghosts of a woman and little boy dressed in Victorian clothing. Though they are most often together, when the boy's specter is alone, he appears sad and confused, wandering throughout the upstairs rooms.

The building is also home to the most gruesome spectral vision witnessed on the Strand. Occasionally at night, people claim to see visions of bodies that float above their heads near the rafters. It is a remnant, no doubt, of the 1900 storm, when waters rose so quickly that bodies were pinned against the ceilings.

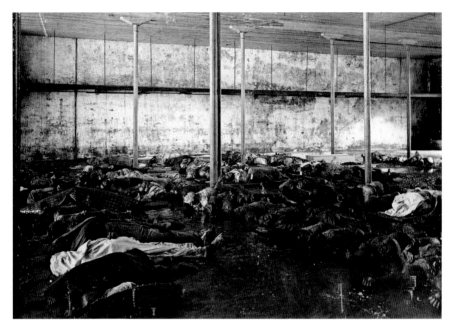

A temporary morgue after the 1900 storm, with victims waiting to be identified. *Courtesy of the Rosenberg Library, Galveston, Texas.*

Linked to the Rogers Building by a shared stairwell, the 1857 E.B. Nichols Building next door shares a haunted status as well.

Its third floor was used as a drill hall during the Civil War to prepare soldiers for battle, and it seems as though some of them have returned.

Numerous reports of ghosts dressed in Civil War uniforms have been given for both locations. They can be seen and heard marching up and down the stairs at night and pacing the street in front of the buildings.

The spirit of a little girl named Annabelle is probably the most active in the pair of structures. She can be heard singing in the Nichols Building back stairwell or sometimes crying softly if she feels frustrated that no one is acknowledging her. She has been known to mischievously play with electronics or open and close doors to get the attention she craves.

Other unexplained phenomena here include the creaking sound of a rocking chair from the top floor and a cold spot on the first floor.

This gathering of ghosts is friendly for the most part, but a menacing presence inhabits the second floor of the Nichols Building as well. He has been known to intimidate women into leaving the building and to cause people to feel extremely anxious. Nothing is known about the origins of this threatening entity.

7

MENARD HOUSE (THE OAKS)

1605 THIRTY-THIRD STREET

Arguably the most famous ghost story of Galveston Island centers on the tale of how a lovely young woman fell down a flight of stairs at the Menard home and died from a broken neck. Taking one glance at the tall, narrow staircase, you can understand how such a story might have originated, but there is no evidence it ever happened.

That's not to say, however, that this stunning estate hasn't seen more than its share of tragedy.

Colonel Michel Branamour Menard, one of the founders of the city of Galveston, built a gracious Greek Revival–style home on the island in 1838 under the branches of ancient oak trees. One of Galveston's most beautifully restored properties, it is considered to be the oldest home in the city.

Menard was married four times, with three of the marriages ending in tragedy.

His first wife, Marie Diana LeClerc, died of cholera en route to Galveston, so she never had the chance to live in the beautiful home.

Afterward, he married his second cousin Adeline Catherine Maxwell in July 1838, when she was twenty-three. She was destined to become a victim of one of several yellow fever epidemics to strike the area.

Pennsylvanian Mary Jane Clemens Riddle became the third Mrs. Menard five years later, but she passed away in 1847.

Finally, Menard married Rebecca Mary Fluker Bass, a widow with two daughters. Menard adopted the girls, and the couple had a son of their own.

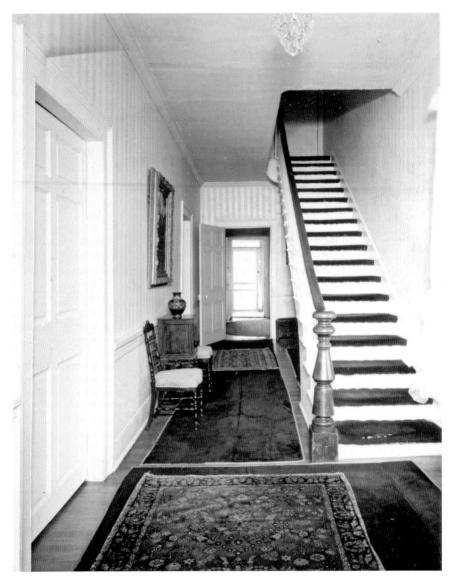

The original staircase at the Menard home, where the legend of a woman falling began. *Courtesy of Library of Congress, Prints & Photographs Division, HABS.*

After having endured so much personal loss, Menard's home was finally filled with children and became the site of many of the community's social gatherings.

On March 26, 1856, the family hosted Galveston's first masquerade Mardi Gras ball at their home. One version of the staircase ghost story is that a

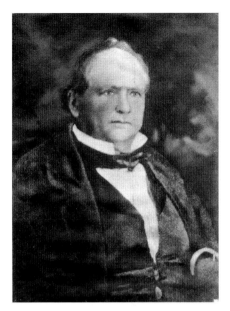

Michel Branamour Menard, founder of Galveston. *Courtesy of the Rosenberg Library, Galveston, Texas.*

woman attending that ball tripped on her gown and fell to her death. In addition to its being unlikely that a guest would have ventured upstairs into the private quarters of the family, no mention of such an accident appeared in a recounting of the party in the local newspaper the following day. The reporter shared a colorful account, describing in vivid detail the costumes of the guests, the refreshments and the decorations. It seems improbable that he would have been more interested in describing what attendees wore than in detailing the death of a woman at the party.

In September of the same year, Menard passed away in his beloved home from cancer of the back. His funeral was held in the front parlor, where the passing of his previous wives had been mourned.

Alone with three children to care for, Rebecca Menard remarried. Her new husband, Colonel John Sidney Thrasher, was an avid spiritualist who hosted numerous séances in the home's parlor, often inviting the public to attend. Some think that this may be responsible for otherworldly activity on the grounds.

The year 1859 is the source of the most popular version of the haunting of the Menard House, in which the colonel's stepdaughter Clara tripped on her wedding gown and fell down the stairs. This can also be dismissed easily, as the young lady moved to Alabama after marrying Frank Lipscomb. Sadly, she died there of yellow fever just five years later, in 1864.

Her sister, Helen, could not have been the unfortunate bride either, as she succeeded in having five children with her husband before dying in her fifties in Georgia.

During the Civil War, the home, also known as the Oaks, served as a yellow fever hospital for soldiers. The Thrashers were living in Georgia at the time, seeking a climate that would aid the health of Rebecca's son. The epidemic's astonishing death rate makes it a certainty that the home witnessed suffering and casualties during the episode.

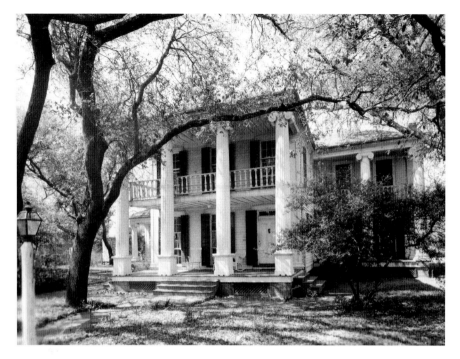

The exterior of Michel B. Menard home, known as the Oaks. *Library of Congress, Prints & Photographs Division, HABS.*

Perhaps the vision of the weeping woman at the foot of the stairs and wandering the foyer is a result of the numerous heartbreaks that occurred within such a short time. Because witnesses seem to relate quite similar accounts of this spirit's brief actions, her appearance is likely a residual haunting and not an actual ghost.

A residual haunting is a sort of replay of energy from a past occurrence thought to be left in a location where particularly traumatic events or emotions have been experienced. If this is the case, visitors have nothing to fear, as the apparition would be no more than a type of movie from the past.

The Menard-Thrasher family returned to the Oaks in 1865, and Rebecca died while visiting New York four years later. She is buried in Old Catholic Cemetery with Michel.

Thrasher remained at the Oaks until his death in 1879.

Edwin Ketchum purchased the Menard home in 1880 for his large family. They were living there when the Great Storm of 1900 struck, killing thousands of Galvestonians. Ketchum, the police chief at the time, had the daunting task of helping organize a city in ruins.

Ten bodies were found on the property of the Oaks when the water receded. Imagine surviving the treachery of a hurricane and the worry of keeping your children safe only to wake up to death all around your home. The bodies could not be identified and were buried in unmarked graves on the grounds. It was a scene taking place all over the island.

Visitors have reported the presence of a small, playful boy in the home, especially in the kitchen, which is not part of the original structure. Could it be that he was lost in the storm? No male child of any of the homeowners is known to have died there.

Objects move and turn up in other places, a reddish light has been seen floating through the dining room and the house alarm inexplicably goes off when no reason can be found.

One of the Ketchum granddaughters tells the tale of visiting the home at age nineteen and sitting on the stairway in a particularly sad mood. Her hair stood on end as the dog sitting behind her began to let out a long, low growl. As she looked up, she saw a woman with dark brown hair drawn back, wearing a long dress with a lace collar and a brooch at the neck. She called to other family members who rushed in to glimpse the figure before it faded away. Though the sighting was unexpected, she found the vision comforting rather than frightening.

The same family member relates that her grandfather used to punish her father when he was a child by making him sit in the "cold spot" at the top of the stairs, telling him to wait for the ghost.

Taking into account that the grounds of the Oaks used to be much larger, it should come as no surprise that sightings happen in surrounding areas as well.

A recent backyard neighbor of the Menard House is convinced that friendly spirits wander the grounds.

One day, the mother was in the kitchen after settling her daughter, who was too young to be in school, down to play in the sunroom. Soon the little girl became very animated, laughing and talking loudly. When her mother asked what she was doing, she replied, "I'm playing with my new friends, Dr. Sam and Mr. Mike." She also described a little girl whose name she didn't know but who was "all wet."

Certainly there was no way a child her age could know of the tragedy that happened behind her home.

Groundskeepers at the Oaks have also spoken of hearing whispering, crying and children's laughter in the yard.

If there are restless spirits surrounding the magnificent home, perhaps it is only because they find peace in this beautiful location.

8

SAMUEL MAY WILLIAMS HOME

3601 AVENUE P

The Texas home of Samuel May Williams was actually framed with northern white pine from his native Maine, brought to Galveston by schooner and reassembled on this site in 1838. Positioned on twenty acres of suburban land, the house features dormer windows and a sequence of French doors that open onto a large gallery to catch the breezes.

The original captain's walk and cupola were destroyed by a fire in 1890, which was luckily extinguished before consuming the rest of the house.

On the ground floor were a brick kitchen with a large fireplace and an oven, a wine cellar and a provision room, but these were all buried in the grade raising after the hurricane in 1900. Seven of the original ten feet of supporting brick piers were covered at the same time.

The lovely, historic home resting beneath oversized trees on a quiet street is deceptive. Its history is fraught with conflict.

Samuel May Williams was one of the most successful businessmen in the early days of Texas. He served as Stephen F. Austin's secretary, and his fluency in Spanish helped to make the Austin Colony a success. Williams also helped to finance the Texas Revolution, became the first banker in Texas and founded the Texas navy.

But before these actions are praised too highly, it is important to understand that he never did anything unless it was, at least eventually, for his own benefit. Williams had the reputation of pinching pennies and ruthlessly foreclosing on mortgages. He never passed an opportunity to turn another man's misfortune into his own profit.

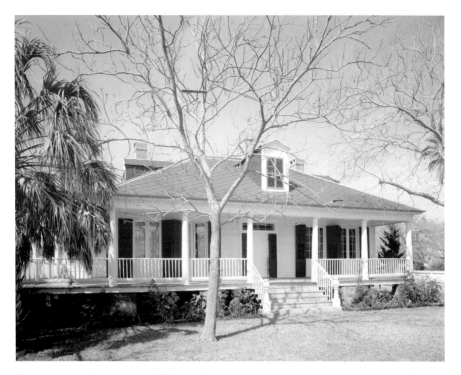

The exterior of Samuel May Williams Home. *Courtesy of Library of Congress, Prints &*
Photographs Division, HABS.

When Austin was imprisoned in Mexico, Williams spent his friend's money recklessly and participated in fraudulent land deals. Even Austin eventually disassociated himself with Williams, disgusted with his lack of ethics.

It's easy to understand why many historians refer to him as the "most hated man in Texas."

His wife, Sarah, suffered the disdain of her community that should have rightly been felt by her husband, but he was rarely home. He often traveled to New York and Washington, and when he was home, he had little time for family due to numerous business dealings.

Sarah was left to manage the house alone and make the difficult decisions, including evacuating her family during the Mexican army's advance during the Runaway Scrap in 1836 and in the powerful 1837 Racer's Storm. She would often hear delayed news of possible perils her husband might be enduring, such as a shipwreck or imprisonment. It was quite a lot for one woman to handle alone. By the time she was forty-seven years old, she was described as a white-haired old woman with failing eyesight.

When Samuel was away from home in 1842, Sarah lived through what might have been one of the most horrific experiences of her life: the family cook tried to kill her by lacing her food with ground glass. The danger was discovered in time to avert tragedy, and Sarah's sister, Mary Jane Scott, was able to seek help in restraining the slave. According to family letters, the slave was locked in the storeroom to wait for Samuel's return so he could decide the punishment. No record of what the penalty entailed exists.

Philip Tucker, who was born in the house during the Civil War, remembered that the former slaves living with his family when he was a boy were afraid of the provisions room and wine cellar, saying that the cook had been confined there for years. While this was highly unlikely, it was certainly based in fact.

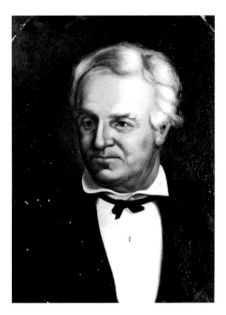

Entrepreneur and businessman Samuel May Williams. *Courtesy of the Rosenberg Library, Galveston, Texas.*

In 1855, little ten-year-old Sam Jr. died in his upstairs room after a brief illness. His funeral was only the first of many to take place in the front parlor of the home.

Visitors to his room now claim to experience drastic drops in temperature and a feeling of dread. A cold spot often manifests outside the doors of the children's rooms. It might be Sarah, stopping by to check on her children.

Little Sam's spirit enjoys rolling a ball across the upstairs floor and bouncing it down the stairs and hall.

Williams's son from a previous marriage, Joe, died two years later at the age of thirty. He had lost an arm in the Mexican War and had tried to become a merchant, but he succumbed to heavy drinking. His spirit has been spotted slowly staggering about the property, one arm swinging.

Samuel May Williams died in the home in September 1858, and his funeral was held in the same parlor where he grieved for his sons. Because he did not leave a will, most of his $95,000 estate was spent on litigation as his surviving four children attempted to settle the property. A lifetime of penny-pinching was all for naught.

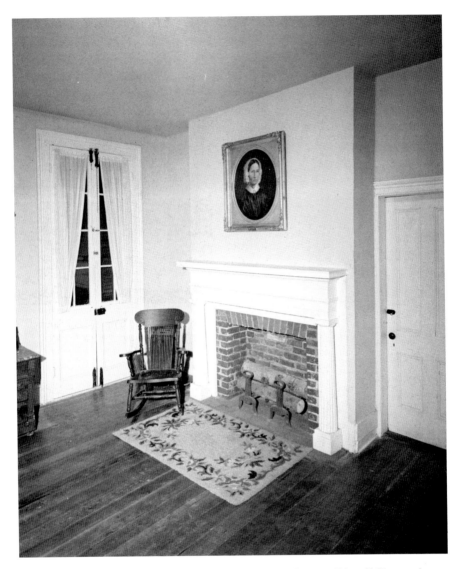

Samuel May William Home parlor. *Courtesy of Library of Congress, Prints & Photographs Division, HABS.*

Within weeks of his death, the family slaves claimed to see his specter rocking in his favorite chair at the southeast corner of the gallery. Few were surprised that he refused to loosen his grip on the household. Williams's disgruntled spirit has also been witnessed pacing along the balcony of the reconstructed cupola and appearing as a misty figure in the windows of the house.

Others have sensed his dark spirit in an upstairs bedroom and seen floating lights and sometimes even a physical manifestation of the former owner.

He occasionally shows his displeasure with strangers in the house in a more abrupt manner by violently rattling lamps, causing blinds to go up and down by themselves and emitting strange noises.

Sarah, who died two years after her husband, appears to be a softer entity that roams the hallways, quietly watching over her household.

Williams's children sold the home to the Tucker family, who remained there until 1952, when the house was closed up and began to deteriorate. The property was eventually sold to the Galveston Historical Foundation, which restored it and operated it as a house museum until 2007, when the declining number of visitors sentenced it to close once again. It is now a private residence.

9

MENSING BROTHERS & COMPANY BUILDING

2118–28 STRAND

B uilt in 1882 for one of Texas's largest cotton factory and grocery wholesale houses, the Mensing Brothers Building was originally topped with a fanciful cornice and two large urns. Its countenance today is a much more subdued stuccoed brickwork, with arched window moldings.

The second floor originally housed a cotton sample room, where the latest crops were bid on and sold. That space has been renovated into trendy apartments with loft bedrooms that overlook downstairs living areas. Residents there have been known to encounter unexplained events.

Around 3:00 a.m. one morning, a couple living in apartment 208 was awakened by a loud crash from their downstairs room. Quickly checking their security, the husband confirmed the door was locked and window was latched. They were alone in the apartment.

Assuming that the noise must have come from their next-door neighbors, who were college students known to keep late hours, the couple returned to bed.

The next morning, however, the couple discovered that the source of the crash was a solid brass, three-foot decorative cannon lying on its side just in front of the window. One of its wheels was severely bent from the impact of a fall.

The cannon had been sitting on the loft bedroom railing, at least twenty feet horizontally and ten feet vertically from the window. If the heavy object had fallen or accidently been nudged over the railing, the weight would have brought it straight down and through a glass coffee table below. To roll to

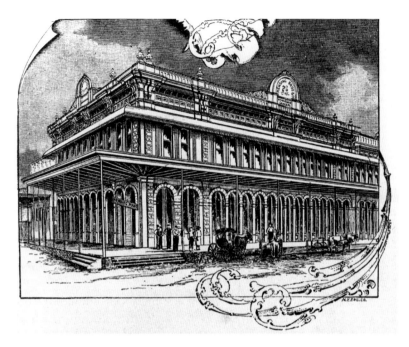

An illustration of Mensing Brothers Building, 1885. *Courtesy of the Rosenberg Library, Galveston, Texas.*

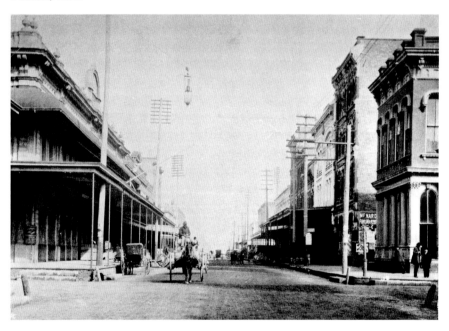

A nineteenth-century view of the Strand, featuring the Mensing Brothers Building on the left. *Courtesy of the Rosenberg Library, Galveston, Texas.*

that spot, highly unlikely with the bent wheel, the cannon would have had to cross a combination of wood and carpeted flooring.

No other objects in the room had moved, and the pair dismissed it is an odd, one-time occurrence.

Not long after that, the husband took a photo of his wife sitting on a sofa under the loft railing. Closer inspection of the photo revealed, hovering over her shoulder, a transparent, whitish figure appearing to have the same shape and size as a human, except that it seemed to be draped in cloth. No features other than the folds in the cloth could be distinguished.

When the husband shot the photo, there was no one else besides him and his wife in the apartment. All the other photos taken that day were crystal clear before and after the image was captured. A smudge on the camera lens would have shown on several photos.

Reviewing pictures of the Strand taken after the 1900 storm seemed to offer an explanation of the ghostly vision to the couple. The Mensing Brothers & Company Building, just like so many other buildings on the Strand, was used as a makeshift morgue in the hurricane's aftermath where hundreds of unidentified bodies were wrapped in shrouds.

Perhaps one of the bodies stored in this building isn't resting in peace.

10
ADOUE & LOBIT BANK BUILDING

2102 STRAND

City founder Michel Menard built a two-story wood frame structure for his office on this lot in 1839. Some of the most important decisions about forming the new city were made there.

George Rains purchased the building in 1868 and moved his notorious Last Chance Saloon to the site, where it remained until the late 1880s. The tavern had a reputation for being the most unruly hangout for sailors coming into the city after long journeys or leaving port again. Rains kept a private museum of sorts at the back of his establishment filled with eerie oddities brought to him from around the world. A shot of whiskey and a strong stomach were said to be necessary to view the collection.

As the Strand evolved toward more substantial buildings, architect Nicholas Clayton designed a richly detailed bank for the firm of Adoue and Lobit in 1890. Joseph Lobit's will in 1911 effectively dissolved the banking partnership, and the building was available for lease.

The structure's exterior was tragically simplified and a fourth floor added in 1919 to suit the needs of the J.H.W. Steele Company. The only remnants of the original Clayton design are the cast-iron columns of the first floor.

In 1926, the name was changed to the Commerce Building, and it became home to various companies and businesses, including radio station KGBC on the fourth floor and the Metropolitan Business College on the third. It now houses retail and loft spaces.

People report experiencing an ominous feeling in the vicinity of the building's elevator, and there may be good reason.

Handyman Oscar Anderson was killed in an elevator accident in the building in 1952, just three years after eleven-year-old Franklin McCray was seriously hurt in the same elevator in a freak accident. Franklin and his six-year-old brother, John, went into the building, entered the elevator and started it to the top floor, where the radio station was located. The boy's foot was caught and crushed between the elevator and the third floor.

It is sometimes said that the rough and rowdy sailors who frequented the Last Chance want their space back, and they decide who is welcome or not.

A salesman in the store space on the bottom floor recently climbed a ladder to arrange stock on the top shelves. As he stood almost at ceiling height, a hand grabbed his shoulder. He whirled around to see who had climbed the ladder without him being aware of it, but no one else was in the room; it would have been impossible for someone on the ground to reach him.

In the same store, merchandise neatly displayed on sturdy wall shelves has been found by morning staffers thrown across the floor, with the shelf undisturbed.

The actions of entities at the Adoue-Lobit often show the entities' frustration with their surroundings.

It may be that Oscar is one of them, trying to keep any more potential victims away from the elevator, which is closed to the public.

11

GALVESTON RAILROAD MUSEUM & SHEARN MOODY PLAZA

TWENTY-FIFTH STREET AND STRAND

Now known as Shearn Moody Plaza, the towering white building that anchors the west end of the historic Strand District incorporates the original 1913 Union Station and the headquarters for the Atchison, Topeka and Santa Fe Railroad. Though these two buildings were once separated by a street, renovations in 1932 added an eight-story north wing and an eleven-story tower joined by a distinctive Art Deco façade.

Five train tracks behind the building, referred to as Union Station, welcomed thousands of travelers each year during peak operation.

The ground floor and railyards house the Galveston Railroad Museum, preserving the old depot and a collection of historic train cars, engines and related exhibits. A waiting area is populated by white plaster statues of people dressed in era-appropriate clothing from the station's heyday and are affectionately called the Ghosts of the Past.

But wherever heavy machinery and people come together, tragedy is a looming reality. Union Station and its tracks are no exception. A particularly gruesome accident began the wandering of one of Galveston's most famous ghosts.

At eight o'clock on Friday night, September 1, 1900, thirty-two-year-old William Watson came to Galveston as a crew member of the steamship *Michigan*. It was the first assistant engineer's second voyage from Brooklyn, and he was ready for adventure.

Donning his dark-brown coat and trousers, best pink-and-white striped shirt and matching suspenders and black tie, he headed onto the

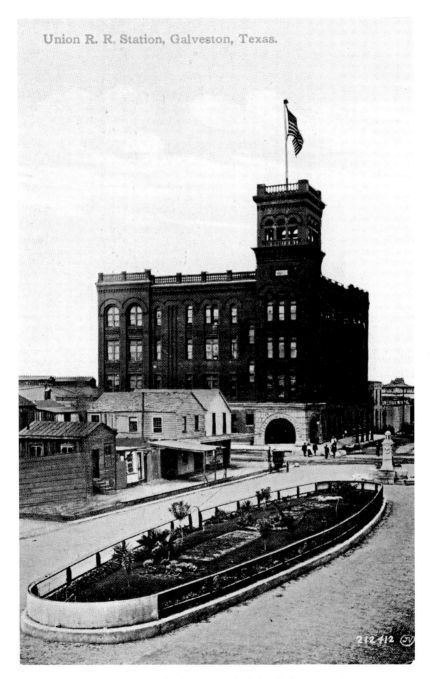

A postcard of Union Railroad Station, 1919. *Author's collection.*

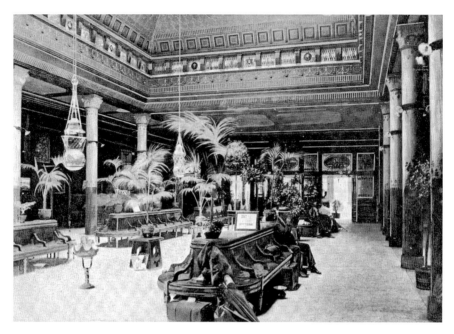

A postcard showing interior of Union Train Station, 1907. *Author's collection.*

Strand to explore the southern city's famous sights and full range of entertainment.

The last time he was seen was by two men who recognized the description of his clothing. He was walking with a "wavering step" along Twenty-Ninth Street in the direction of the wharf around 10:30 p.m. Fifteen minutes later, he would meet his grisly fate.

Approaching the crossing of Twenty-Ninth Street and Avenue A at midnight, Foreman Frame of the crew of switch engine no. 765 spotted a body lying on the track. He signaled the engineer to stop, but before the locomotive could be brought to a halt, it struck the body and shoved it about twelve feet west and to the side of the track.

When they walked back to investigate the sighting, the men found a decapitated body mangled beyond recognition. The unidentifiable man had been dead less than an hour, obviously killed by a previous train.

An excruciatingly detailed account of the victim's remains and clothing, right down to the color of his underwear, was gathered by police, and the description was taken along the Strand and to visiting ships to make an identification.

The captain and steward of the *Michigan*, which was docked one block from where the accident occurred, were called to attempt an identification, but they failed to recognize their shipmate and returned to their ship.

Railroad crews and police discovered the head three hours later by following the rails out of the yard and pieced together the horrible clues from the night's events.

Struck down by a train, Watson's head had been severed, leaving the body behind and carrying the head beneath its wheels from Twenty-Ninth to Fourteenth Street.

As the train jolted to a stop at its destination, the head was knocked from its position and rolled onto the ground beside the tracks, where it was found at 3:00 a.m. A derby hat was still securely sitting on the head.

Popular versions of the story describing how he had been pulling a stunt on a railcar when he was hit are merely elaborations, as there were no witnesses to the late-night horror.

Watson was buried by his crewmates in Lakeview cemetery, never to see his wife, Annie, and small daughter again. If his grave was ever marked, the stone and location have been lost to time.

The unfortunate man reportedly haunts the railroad museum in the form of a poltergeist, venting his frustration by tossing items, making strange noises and moving objects from place to place.

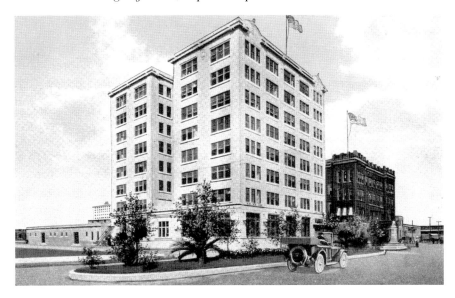

A Union Railway postcard, 1916. *Author's collection.*

Seven years after Watson's death, a train crossing the very same intersection killed a mother and son.

In Galveston on vacation from Beaumont, the family had hired a chauffeur to drive them around to see the local sights. After an outing to Pier 29 to view a large German steamer in port, they were on their way back to their rooms at the Royal Hotel. The automobile was moving slowly, and just as it approached the tracks, a fast-moving train came down. The signalman waved and yelled, trying to alert the driver, but he went unnoticed. When the startled driver finally spotted the danger, he slowed down rather than sped up to clear the tracks.

In a panic, the woman in the group grabbed her little boy and jumped from the car. Unfortunately, she leaped right into the path of the train just as the car cleared the tracks by less than a yard. The two were killed instantly.

She might be the female spirit holding a youngster that is occasionally seen standing in the depot waiting room with a forlorn expression, just before disappearing.

Ironically, in 1897, when local businessmen lobbied to add the section of track that crossed over Avenue A, the wording used was that "such an addition could not possibly hurt anyone."

The adjoining building has seen its share of tragedy as well.

In 1988, the Gulf Coast Regional Mental Health & Mental Retardation Center was located on the sixth floor of Shearn Moody Plaza.

An eighteen-year-old female patient at the center was dropped off in front of the building by her father one morning, just in time for her appointment. No one quite knows or has revealed what happened in the next few minutes, but at 9:08 a.m. the distraught girl jumped to her death from the sixth-floor ladies' bathroom window. Three employees in an eighth-floor office witnessed the fall.

She was found, unconscious and bleeding, lying on a second-floor metal-and-gravel canopy on the west side of the building and died at the hospital without ever having regained consciousness. Whatever torment she was experiencing, she took with her.

The girl's apparition has been seen running down the sixth-floor hallway, looking anxiously over her shoulder. She has also been spotted sitting on the washroom windowsill with one leg dangling out the window, just before vanishing.

A young boy killed while playing on the tracks at Twenty-Eighth Street before the turn of the last century now runs across the polished floors of the

depot, his footsteps echoing off the walls. His laughter is often heard as he sneaks up on visitors or brushes their arms.

In the 1990s, the police department received several telephone calls from the third and fourth floors of the building, hearing nothing more than breathing and the sounds of music from the 1920s in the background.

These spirits are far from being alone in the building and railyards, and on some evenings, the terminal might be almost as crowded as it was a century ago. The entities that remain at this location are harmless and sometimes even playful, so don't be surprised to hear humming, feel a chill or notice a tug on your sleeve during your next visit.

12

MAISON ROUGE

1417 HARBORSIDE

Jean Lafitte, the notorious "Terror of the Seas," once called Galveston home, and many will insist he's still there.

In exchange for aiding General Andrew Jackson at the Battle of New Orleans during the War of 1812, President James Madison gave a full pardon to Lafitte and his men for their previous pirating activities.

Ready for his next adventure, he and his followers settled in Galveston in 1817, renamed it Campeche and appointed himself its leader.

He proceeded to build a two-story headquarters that he painted red and dubbed Maison Rouge. The second story was designed with openings for cannons, and the entire building was surrounded by a moat. Luxuriously furnished with plunder from captured ships, it was a castle fit for the Prince of Pirates.

Lafitte and his men strategically used their position on the gulf to capture slave ships and sell the slaves in New Orleans. It was a lucrative time, and for a while Campeche thrived, its population growing to about one thousand followers of Lafitte.

Lafitte also reportedly married a woman named Madeline Regaud in Campeche, who bore him his only son, Jean Pierre Lafitte. Sadly, Madeline died in 1820, and rumors persist that she was buried surrounded by treasure.

By 1821 the U.S. Navy was determined to put a stop to the colony's piracy and dispatched the schooner *Enterprise* to intercede.

Lafitte realized his group was no match for the naval forces and abandoned Campeche, though not before he burned his home, fort and village to the ground. No one else would prosper from his expulsion.

On May 7, 1821, Lafitte and his men sailed away on his flagship vessel, the *Pride*.

Treasure hunters descending on the island just a year after Lafitte's departure were among the first to report encountering the pirate's ghost. One man claimed to have been choked during the night as he and his friends sought refuge in an abandoned house. He described the ghost as wearing a red coat and breeches.

During the Civil War, sailors on a Union gunboat unloading supplies saw a blue light glowing in the fog as their ship passed a pier. When the light came closer, they saw it was a hazy ship with the name the *Pride* emblazoned on the side.

The land where Lafitte built his home passed through several hands before being sold to a ship's captain named Frederick William Hendricks in 1866, who was enamored of the stories about the famous Lafitte.

On the foundation and cellar left by Maison Rouge, Hendricks built Hendricks' Castle, also known as Twelve Gables, which was purportedly a replica of the pirates' original structure. It even featured the crossed anchors seal of Campeche on either side of the front stairs.

After Hendricks's death, the property fell into disrepair but was still somewhat habitable. A woman named Anne Peterson lived there in 1907 but told friends she had to move because of the ghosts of pirates.

The wooden structure was demolished in 1952, but the lower stone portion is still visible because the post-1900 island grade raising stopped one alley to the east of the site. Unfortunately, Hurricane Ike knocked down the eastern wall in 2008.

The Lafitte Society, a group of local history enthusiasts, held a séance at the ruins one Halloween, and one of their members allegedly began speaking in a language that none of the attendees understood.

Crews of offshore ships and small craft claim to have heard shouting and the sound of flapping sails coming from ghost ships. The sightings are thought to be a bad omen because the last time the *Pride* was seen was just before Hurricane Katrina struck the Gulf Coast.

One more story attached to the Lafitte legacy is a bit more fearsome than spectral ships sailing in the distance.

Legend has it that a banshee dubbed the Galveston Hag roams the Strand at night, with her long, straggly hair blowing in the breeze. She is the ghost of a beautiful woman named Magdalena who was once in love with Lafitte and called on the devil to trade her soul for his love. She was tricked into the contract, only to find that Lafitte's heart was guarded by

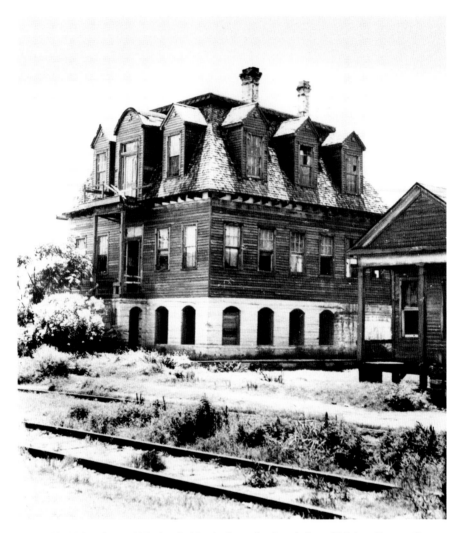

A pre–Civil War photo of Twelve Gables, built on the foundation of Maison Rouge. *Courtesy of the Rosenberg Library, Galveston, Texas.*

a voodoo protection spell he had acquired while in New Orleans. The pirate felt nothing for the pitiful woman and eventually married another. Distraught and angry, she is doomed to wander the streets screaming obscenities at any who look directly at her.

13

TREMONT HOUSE

2300 MECHANIC STREET

The Tremont House located on Ship Mechanics Row is actually the third Galveston inn to bear the Tremont name.

The first Tremont opened in 1839, before Texas was part of the United States. Located on Postoffice Street and featuring long galleries extending the length of both floors, it was a mecca for traveling dignitaries, politicians and soldiers. The hotel was only one of a number of buildings that unfortunately burned to the ground during a raging fire in the summer of 1865, leaving behind nothing but ashes.

In 1871, a group of citizens created the Galveston Hotel Company and hired architect Nicholas Clayton to design what was thought by many to be the grandest hotel in the South. The following year, Galveston's second Tremont opened on the corner of Twenty-Fourth and Church Streets, boasting of an in-house barbershop, saloon, billiards room and steam-powered elevator. During the storm of 1900, hundreds took refuge there, and Clara Barton used it as her headquarters during the city's recovery. The building eventually fell into disrepair and was demolished in 1928.

The third and present incarnation of the Tremont House opened in 1980. After the addition of a fourth floor, a four-story atrium, a rooftop bar and a skylight, the elegant establishment, created by joining the 1879 Leon & H. Blum Building and Belmont Hotel (originally constructed in 1870 as a commercial building), now occupies an entire block.

The lobby gathering space features an exquisite rosewood bar once tended by Henry Toujouse, who was the barkeeper and proprietor of the

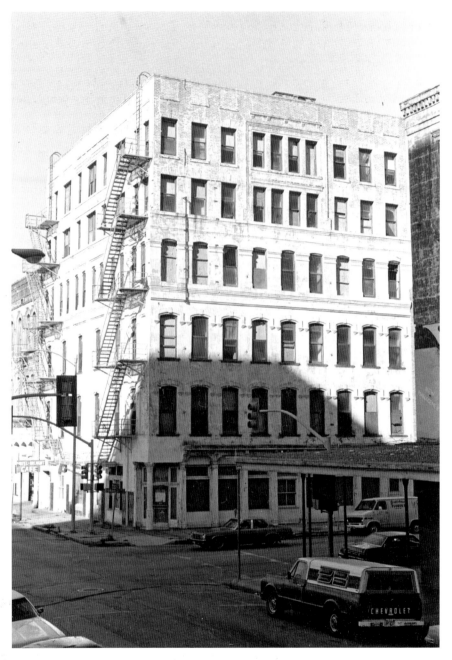

The Belmont Hotel, 1875, now part of the Tremont House. *Courtesy of the Rosenberg Library, Galveston, Texas.*

Opera House Saloon in the basement of the Tremont Opera House. After the opera house closed its doors, Henry took the bar with him and opened Henry's Café at the Stag Hotel.

Henry sold his beloved bar and retired in 1913. Lost and alone without the work that he loved, he committed suicide in his bathtub five years later at the age of seventy-five.

His ornate bar was found in disrepair at a local tavern in the 1960s. It was rescued and restored to its former beauty. Now installed at the newest Tremont, the bar is named in his honor.

Henry may be more than just a memory, though, as staff and guests have witnessed paranormal activity in the bar almost since opening day.

On Valentine's Day one year, each of the ladies on the bar waitstaff was given a long-stemmed rose by management. Gathering around the bar after closing, one of the ladies suggested they leave their roses for the bar ghost. One waitress, scoffing at the idea of giving up her flower for a silly ghost, laid it across the corner of the bar as she retrieved her purse. An unknown force immediately sliced the bloom off the rose, leaving the startled woman with only a thorny stem.

The impish spirit of a little boy fondly called Jimmy by the staff plays in the kitchen, lobby, elevators and back alley of the establishment. He is rumored to be the ghost of a child who was run over in front of the Blum Building in the 1880s.

Jimmy is believed to be the cause of glasses that move by themselves across the bar, sometimes tumbling to the floor. Henry probably enjoys the company.

New employees usually experience Jimmy within a month or two, seeing the youngster out of the corner of their eyes.

One woman in guest services saw a little boy playing behind a guest who was checking into the hotel. When he walked away, the boy didn't follow and seemed to disappear. When the employee later asked the guest about his son, he said he was alone and hadn't seen the child.

The most talked-about spirit at the hotel appears as a Civil War soldier in full uniform. Seen for over thirty years, he marches up and down the lobby in front of the elevators and back toward the staff offices, his ghostly steps echoing off the marble floors. His countenance has also been seen in the bar and dining areas.

An intern from out of the country was gathering ice for room service when he heard a woman crying in a stairwell of the fourth floor. As he approached the sound to investigate, a strong rush of air burst past him, and the sobbing stopped.

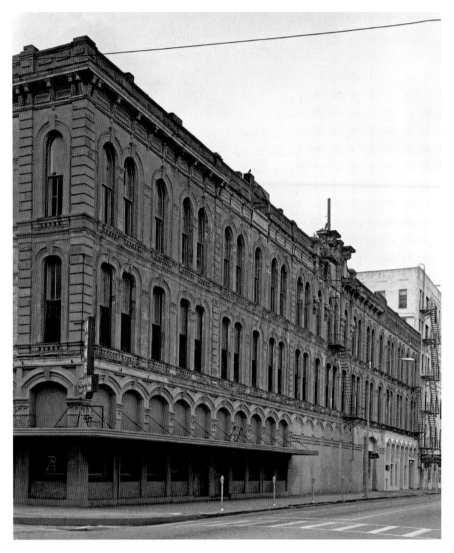

The original Leon and H. Blum Building, now part of the Tremont House. *Courtesy of Library of Congress, Prints & Photographs Division, HABS.*

More than once, housekeeping has watched an older lady dressed in black walk out of a restroom in one of the guest rooms on the Belmont side while they are cleaning. The witnesses have always been sure they were alone at the time.

The phantom of a male victim of the 1900 storm is a bit more unnerving than his fellow ethereal residents; he creates cold spots on the

third and fourth floors. Especially active whenever there is heavy rain, lightning or windstorms, he attempts to alarm witnesses in order to warn of impending danger.

Roaming the hallways and visiting rooms, he turns showers, lights, televisions and ceiling fans on and off while guests attempt to sleep. The occurrences have even been known to happen in unoccupied rooms, through reports from people staying in neighboring rooms.

Loud claps of thunder cause the spirit to elicit loud moans, and a sleeping guest might hear breathing or whispering in his or her ear.

Following Hurricane Ike, guests on the fourth floor described being awakened by the sound of their doors being shaken by loud pounding. The incidents were followed by the sound of one-footed stomping in the hallway accompanied by a distinct dragging noise.

One guest reported hearing someone crying for help and rapping from outside the window, which could almost be explained, except for the fact that his room was on the third floor.

Most of the ghostly reports originate from the east side of the hotel, which was originally the Belmont. More than half a dozen retired seamen died in rooms there in the 1960s alone. One unfortunate fellow mysteriously fell from a window on the top floor at four o'clock in the morning.

A few rooms at the Tremont House have ghosts with their own specific habits.

Room 219's roguish entity sometimes unpacks the luggage of guests, who find the contents strewn across the floor when they wake up.

In 271, guests smell old-fashioned perfume, feel cold drafts and get an impulse to leave the room. On several occasions when housekeeping has knocked on this door, a woman asking to be left alone has responded to them. When they reported the guest to the front desk, they were informed the room was unoccupied.

A shadow figure, along with flashes of light, has been seen in room 424, and the water has been known to turn itself on in the middle of the night.

A presence is felt in room 474, and a burst of light can sometimes be caught on camera.

Guests at the Tremont House can be assured of being treated like royalty by staff and that they will never be quite alone.

14

Nicaragua Smith

BROADWAY CEMETERY HISTORIC DISTRICT

As immense and historical as Galveston's Historic Cemetery District is, there is only one ghost known to roam the grounds.

No one seems to know where Thomas "Nicaragua" Smith was born or raised. What is certain is that in 1856, he joined an ill-fated filibustering expedition to Nicaragua as a soldier of fortune. Surrendering to the U.S. Navy, he became a prisoner of war and was eventually released in New Orleans. It was there that he was tagged with the nickname "Nicaragua."

Nicaragua made his way to Galveston, where he earned a reputation as a notorious thief, ruffian and arsonist. Accounts from 1860s newspapers state that "his associates were not of the type to inspire confidence in his character."

In the volatile days after Texas withdrew from the Union in 1861, a crime wave hit Galveston, with Nicaragua at the center of the action. Arrested at various times for burglary, arson and even murder, the scoundrel evaded prosecution due to an overwhelmed police force and justice system.

Though they were undoubtedly reprehensible, the tales of his exploits were often exaggerated by the community.

On one occasion, it was said the bold thief stole $350 in coins from under Mrs. T.C. Saunders's pillow and $250 in gold from Mrs. Croycroft's mattress while the ladies slept.

A group of citizens who took matters into their own hands apprehended Nicaragua and others accused of looting homes left vacant by families who had escaped to the mainland during the Civil War. They were marched

Galveston Historic Cemetery District, location of Thomas "Nicaragua" Smith's unmarked grave. *Author's collection.*

down to Central Wharf and placed aboard a steamer bound for Houston, with the explicit order not to return to Galveston.

Having few options after he ran out of money, Nicaragua joined a Confederate artillery battery and was coincidentally stationed in Galveston on Pelican Spit.

When he realized that the rigorous garrison life did not appeal to him, the rogue stole a boat, rowed into the bay to a Union blockade ship and surrendered. The city only realized his true identity after he made his escape.

He swore allegiance to the Union and was taken to New Orleans, where he enlisted in the First Texas Regiment of U.S. Volunteers. He could not know at the time his new unit would soon board the Federal transport *Cambria*, headed for Galveston.

His third visit was far from a charm.

Confederates regained control of Galveston during a battle on New Year's Day 1863, after two months of occupation by the Union navy. Unaware that the city was no longer under Union control, the captain of the Federal transport sent Smith and a group of seamen ashore one foggy night to bring a pilot back to the ship. Smith was immediately recognized and put in irons.

Court-martialed for desertion, he was sentenced to death before a firing squad. While two of his comrades escaped, another two managed to be paroled.

At dawn on January 8, the convict was taken from the guardhouse and loaded into a wagon beside his wooden coffin. He was then driven to an open field east of the city cemetery, where Thirty-Eighth and Broadway is now located, escorted by five hundred Confederate soldiers.

With grand ceremony, the troops formed a hollow square formation with Smith's wagon positioned at the open end, and a six-man firing squad opposite him. Carriages filled with Galvestonians surrounded the formation, thinking that the execution would be fine entertainment.

Defiant to the end, Nicaragua tapped his foot as the band played taps, grinning and swearing. After refusing a blindfold, he was asked if he had any last words. Although none of the newspapers would reprint them due to vulgarity, letters of eyewitnesses attest that he requested to be buried face down so the Confederates could kiss his backside.

He stood beside his open coffin, continuing to rant as the order to fire was given at noon. When the gun smoke cleared, his stout body could be seen lying across the coffin pierced with six musket balls.

Immediately pronounced dead, the deserter was rolled into the coffin and buried in an obscure corner of the pauper's burial ground, where Oleander cemetery is located today. The location of the unmarked grave has long since been lost.

General Bankhead Magruder, the Confederate officer who approved Nicaragua's sentence, is buried in the same group of cemeteries. The general's impressive monument must surely be a thorn in Nicaragua's side.

Legend has it that if you visit the cemeteries on January 8, you can hear a Union soldier loudly curse the firing squad that put an end to his misadventures.

15

WITWER-MOTT HOUSE

1121 TREMONT

Captain Marcus Fulton Mott, a prominent Galveston lawyer and veteran of the Civil War, built this grand Victorian mansion on the island's east end in 1884. The home is as famous for invented ghost tales as it is for those that actually take place there.

Active in community affairs, the colonel was respected for his involvement in executing Henry Rosenberg's will, which gifted the city with the Rosenberg Library, an orphanage, an old women's home and public fountains.

Mott died in his home in 1907.

One particularly detailed story that is popularly told about the home involved a son of Mott's named Abe. The tale relates that Mott's son murdered three women and hid their bodies in the well on the north side of the property. The women were a neighbor girl who shunned Abe's advances, a maid who found out about the girl's murder and eventually Abe's own girlfriend. One version even goes so far as to assign names to the victims. A Ouija board session in the 1970s supposedly contacted Mott, who said that he would be unable to rest until the bodies had been found and the crime revealed. A different version of the story adds that Abe murdered his own father after confessing to him; however, a quick review of history washes away the possibility of these stories, as colorful as they may be.

Marcus Mott and his wife, Rowena, did not have a son named Abe. Of their four children, only one was still living when Mott passed away at home due to injuries resulting from a fall from a streetcar. Lillian Mott

Witwer-Mott House, during restoration. *Author's collection.*

Cash was Mott's only surviving child. Her brothers were Herbert, who died at one year old; Clarence, who was stillborn; and Marcus Jr., who also lived for only one year.

There was no son named Abe, no surviving son, no Galveston families with the last names given for the victims and Mott himself was not murdered. To disprove the story further, original maps of the property show no well existed.

Descendants of the Mott family sold the home to C.F. "Tommy" Witwer in 1943, and he used part of the residence for his photography studio for years.

The most malicious stories about occurrences in the house take place during this period, including audible warnings to leave the house, pictures flying off walls, heavy furniture moving and the sound of heavy footsteps pacing in the attic. These violent manifestations thankfully appear to have ceased.

During the same years, children who lived in and visited the home often saw the spirit of a kind man they called "the captain." Far from being afraid of the vision, the youngsters felt protected by his presence. Their descriptions of his appearance are strikingly similar to known photos of Colonel Mott.

Tommy Witwer died at home in 1989.

The devoted current owner of the home relates that any spirits his family has experienced in the Witwer-Mott House are all friendly, although when he purchased the home fifteen years ago he didn't believe in ghosts.

He does now.

The first thing he noticed was that when he would wash his hands in the restrooms, the toilets would flush by themselves. He tried to shrug this off as an anomaly—until realized that it happened in every bathroom.

The house was uninhabitable when first purchased, so the owner came to the island on weekends to begin the work of restoring the grand home. Because there was no air conditioning, he would open the upstairs dormer windows to ventilate the building. He closed the windows before leaving after the first weekend of work only to return the following weekend to find them open. Though he was certain he had closed them, he also realized he may have been tired and forgotten.

That weekend he was sure to close the windows, but upon his return the next week, they were open again. Thinking that vagrants might be getting inside the home, he made a trip to the hardware store for latches to secure the windows from being opened from the outside. Even this didn't deter the windows from opening before his next return. After so many efforts, he decided to leave the troublesome windows open. The next weekend, he found them closed and tightly latched. That's when he began to believe that he might not be alone in the home.

Items in the house have a tendency to disappear and reappear elsewhere, but it seems to be done in fun.

One evening as the owner returned with a half dozen people, one man announced that he was going upstairs to watch television. At that moment, the television and surround sound upstairs turned on.

When watching television on another occasion, the owner was surrounded by his four dogs sleeping on the sofas. Simultaneously all four animals sprang from their naps, ran over to an empty wingback chair and circled it, snarling.

More surprised than alarmed, the owner takes these events in stride.

Not immediately visible from Tremont Street, the home is situated behind a small strip center of businesses, including that of the owner.

16

BOARDINGHOUSE

AVENUE K AND 23ᴿᴰ STREET

If this rambling structure is a home to ghosts, they have plenty of room to roam.

Built on four lots, the 7,800-square-foot, mansard-roof building was built in 1912 by George C. Smith, a telephone operator at the *Galveston Daily News*. Designed by his wife, Louise, the twenty-seven-room boardinghouse featured speaking tubes and call bells in all guest rooms.

Fortunately, the building has lasted much longer than the Smith marriage, which ended in divorce in 1915.

Located next door to the haunted Witwer-Mott House, this imposing establishment has a colorful reputation of its own, accented with creaking doors and floorboards and enough cobwebs to make a Hollywood set designer jealous.

After the Smiths moved on, a widow named Jessie Perry operated the structure as Perry's Place boardinghouse for many years.

As might be expected for a house that has hosted boarders for the past one hundred years, several people have died in the home, including a few retired seamen. But though they've technically "passed on," they are living it up now.

The property is notorious for poltergeist activity, especially on the third floor. Chairs stored on this level have moved around by themselves, only to be rediscovered in different areas and in different configurations. It's also the level that seems to be the source of rhythmic tapping, unexplained footsteps, eerie laughter, conversations and sounds of dancing and faint music.

Above: The boardinghouse at the corner of Avenue K and Twenty-Third Street. *Author's collection.*

Left: Detail of the boardinghouse, in need of restoration. *Author's collection.*

People are often spotted passing down the hall but can only be seen out of the corner of witnesses' eyes. There is no one there when someone attempts to look directly at the motion.

When a group of teenagers decided to have a party in the abandoned building, one boy was so frightened by something he saw that he jumped from a second-floor window. Luckily, he was uninjured. The ethereal "residents" probably don't appreciate trespassers.

Recently updated and renamed the Normandy Inn, the old boardinghouse has since suffered damage and neglect and is looking for its next owner.

17

WALMART

6702 SEAWALL

What does Walmart have to do with one of Galveston's most tragic losses? Quite a bit, it seems.

Galveston's most heartbreaking loss during the nation's greatest natural disaster happened on the site where Walmart now stands.

St. Mary's Orphanage was established in 1867 at St. Mary's Infirmary by the Congregation of the Sisters of Charity of the Incarnate Word, who were summoned to the city to help care for the numerous victims of a yellow fever epidemic.

The sisters relocated the orphans to a more permanent location in 1874 three miles west of Galveston, between what is now Sixty-Seventh and Sixty-Ninth Streets at the seawall. The new location was intended to keep the children away from the dangers of outbreaks as well as being an ideal spot to grow and play.

Two large, two-story dormitories with balconies facing the gulf were built on the former estate of Colonel Farnifalia Green, behind tall sand dunes anchored by salt cedar trees and sea grass.

By 1900, ninety orphans, many orphaned by yellow fever, and ten nuns lived at the beachfront complex.

As the famous hurricane hit, the sisters brought all of the children to the newer, sturdier girls' dormitory. They led the group in singing the French hymn "Queen of the Waves" in order to distract the youngsters from the storm outside.

Rising water had forced the group upstairs by six o'clock in the evening, and the one-hundred-mile-per-hour winds began to shake the wooden structure.

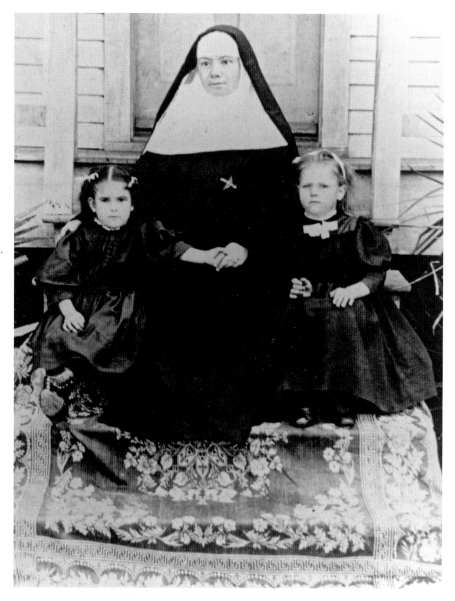

A nun from the Sisters of Charity Order, with two orphans in her charge. *Courtesy of the Rosenberg Library, Galveston, Texas.*

Still singing hymns, the nuns tied clotheslines around the waists of the children and then lashed nine each to themselves. One survivor remembered Sister Katherine holding two of the smallest children in her arms, promising not to let go.

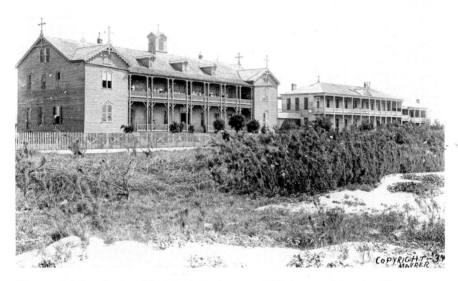

The wooden dormitories of St. Mary's Orphanage, 1890. *Courtesy of Rosenberg Library, Galveston, Texas.*

As they finished tying the knots, the winds dashed the boys' dormitory to pieces, sending debris battering against the orphans' shelter. The impact collapsed the girls' dormitory building and forcefully sucked the sisters and children into the surging water.

Only three boys survived, by clinging to a tree throughout the night.

In the following days, the bodies of the nuns were found scattered across the shore, half buried in the sand. The heavy, coarse dresses and habits these brave women wore had made it impossible to stay above the water once they were wet. Each nun's group of children were still tied to them, and Sister Katherine was still devotedly embracing the two little ones she had vowed not to release.

The orphanage victims were buried where they were found.

Reports of ghostly occurrences have been taking place at Walmart for years, and most accept them as the restless spirits of orphans lost in the hurricane. Most are heard but rarely seen.

One particularly sad manifestation is the whimpering sob of a small girl who cries for her mother. Usually heard by several people at a time, no amount of searching reveals a living child at the source of the noise. It eventually fades away.

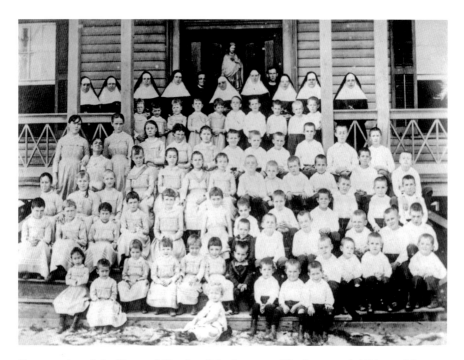

Congregation of the Sisters of Charity of the Incarnate Word nuns and children of St. Mary's Orphanage before the 1900 storm. *Courtesy of the Rosenberg Library, Galveston, Texas.*

Kids will be kids, even if they are ghosts, and the sound of children running up and down the aisles laughing can be heard when no living child is near. Toys in the store are regularly misplaced, and things fall from neatly stacked shelves.

One child in particular seems to enjoy bouncing balls, and when a real one isn't available, he uses his own invisible version.

Employees of the store attest that many of the manifestations increase after 1:00 a.m., when the storm was at its height.

The automatic doors at the entrance occasionally open and close repeatedly, and the confused faces of patrons are probably quite amusing to the little spirits.

After Hurricane Ike, FEMA workers were allowed inside the heavily damaged store to retrieve supplies. The female workers reported hearing children's laughter, wheezing and coughing. Afraid that youngsters had snuck into the building, they searched but found nothing. The amount of muck on the floor would have made it impossible for any physical being to elude the searchers for long.

18

The Hotel Galvez

2024 SEAWALL

K nown as the Queen of the Gulf, the Hotel Galvez has been a romantic tourist destination since its opening in 1911. The timeless beauty is positioned directly across from the beach, with a sweeping lawn and elegant interior.

Plans to build the Galvez began in 1898 after the large Beach Hotel was lost to fire. After the storm of 1900, city leaders accelerated plans to erect the gracious hotel as a means of drawing tourists back to the island.

The resort has played host to numerous presidents and celebrities through the years, as well as thousands of tourists.

Among the guests of this showplace are spirits that have decidedly chosen not to check out and have been experienced by generations of guests and hotel staff, making the Galvez one of the most haunted hotels in America.

The most legendary ghost at the Hotel Galvez is the Lovelorn Bride, Audra.

In 1955, the young woman checked into room 501 at the Hotel Galvez to await the return of her fiancé, a mariner who had been called to duty just days before their wedding.

Each day, she would leave her room, take an elevator to the eighth floor and climb the ladder to the west turret of the hotel to watch the waters for the return of his ship. At the time, the turrets were open to allow the gulf breezes to circulate throughout the building because there was no air conditioning.

After weeks of watching the horizon, the bride-to-be received heartbreaking news: her lover's ship had been lost in a storm at sea and there were no survivors.

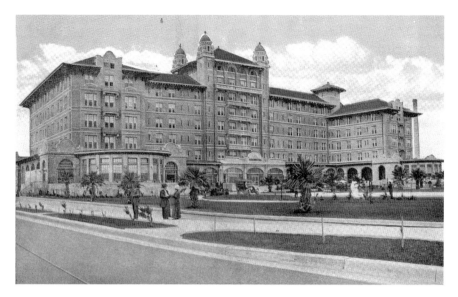

A postcard of the Hotel Galvez, 1914. *Author's collection.*

Refusing to believe the report, she continued her vigil for days but eventually sank into a depression and abandoned hope. She traveled one last time to the turret high above the gulf, where she was found a few days later. Audra had hanged herself in despair.

The tragedy was compounded when her fiancé, who had been rescued by a passing ship, returned to marry his betrothed.

Audra still waits at the Galvez, not realizing her love is waiting for her on the other side. She walks the same path to the turret, although its access has long since been sealed. Her footsteps are heard in the hallway on the fifth floor, and the scent of her gardenia perfume lingers in the air.

The rooms no longer use keys since electronic access panels have been installed, but when Audra doesn't want to be disturbed, nothing will open the door to room 501. One guest returned to the front desk to have a problematic electronic key inspected. When the staff scanned the key, the display read, "Expired 1955."

Guests in the infamous room have also been disturbed with the phone ringing all night. When they report it to the switchboard, no calls show up as being received for that room.

Whatever room visitors stay in, one point of interest is the portrait of Bernardo de Gálvez, for whom the hotel and island are named. It hangs at

the west end of a long hallway on the ground floor and has a reputation for being ill tempered.

People who approach the painting often feel uneasy or chilled. It may have something to do with the fact that his eyes follow visitors as they walk past.

The painting doesn't appreciate being photographed unless it is asked permission first; otherwise, it's quite difficult to get a clear picture.

If Gálvez is truly angered or offended by someone's behavior, beware! The image of a skull will seem to superimpose over the face. This has occurred when people look directly at him or sometimes shows up in a photo later. If spooky paintings aren't your cup of tea, it may be best to avert your eyes all together.

Displayed in the same hall is an enlargement of one of the original press photos taken in the lobby just before the hotel's grand opening. Look closely at the doors in the center of the photograph. A faint image of a slender man tipping his bowler hat can be seen standing in front of the French doors in the center of the image. It isn't a reflection in the glass, because no one is standing nearby. Perhaps it's a guest of the Beach Hotel, which stood on the same site years earlier, checking in to the new accommodations.

Audra has plenty of company on the ghostly guest register. The list of entities at the Galvez reads like a cast of movie characters: the businessman in the penthouse; a blond teenage girl in a violet-sprigged organdy dress, with violet sash, hair bow and high-button shoes who smiles as she rides the elevator; an elderly man occasionally seen scowling back from the mirror in the lobby men's room with a mournful countenance; a man seen standing in the corner of the hotel's laundry room; a tall man who stands gazing out over the swimming pool; a woman in white wandering the music room; and a group of ladies in Victorian dresses who sit in the Terrace Ballroom as if they are waiting for an event to begin.

The specter of one little girl is particularly active in the hotel, and she is familiar to staff and regular guests. Usually seen in the early morning, the pig-tailed blond child, who stands about three feet tall, wears a white dress and black Mary Jane shoes and carries a large red rubber ball that she bounces as she walks. Even when she isn't visible, the sound of the ball can often be heard. She likes to play outside the spa, where the hotel's soda shop was once located, and occasionally whispers a hopeful "ice cream" as people pass.

She is also spotted in a second-floor hallway but reacts more shyly there. Beginning as a soft ball of light, she allows herself to be seen only for a moment before disappearing again.

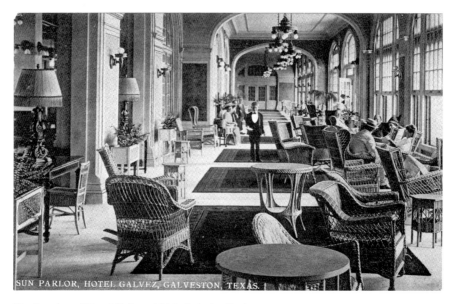

The interior of Hotel Galvez, 1918. *Author's collection.*

Numerous victims of the Great Storm were swept away and back to shore on the property, and some of their ghosts have claimed it as their permanent home.

Sister Katherine, who died trying to save nine orphans, is one of those found at this location. A nun is sometimes seen on the south lawn looking out to sea when a major storm is approaching, protective of the children's spirits that are too confused to move on.

A number of ghostly youngsters that wander the hotel playing pranks are thought to be her former wards from the orphanage. Groups of high-pitched voices are heard chatting excitedly, but upon investigation, no children are ever found.

The staff of the spa often has to repeatedly clean tiny handprints from the bottom of the glass door.

The front desk is accustomed to calls from guest rooms reporting showers that repeatedly turn on and off, toilets that flush by themselves and televisions that turn themselves on. These types of luxuries still appear to be a novelty to children from 1900.

When guests open their doors to scold youngsters running up and down the hallways on the fifth floor, they rarely see anyone there.

Not usually meaning any harm, the mischievous little ones can sometimes make a mess. Wine bottles have been known to fall out of horizontal racks,

dishes move in the restaurant, candles blow out without a breeze to extinguish them, glasses fly off tables and empty trays tip and fall from perfectly sturdy stands that remain upright. Once, after an entire shelf of wine bottles exploded in the cellar, their replacements exploded just a few minutes later.

Although most of the entities seem happy with their surroundings, there are a few that are less content.

A bartender on the afternoon shift heard the frightened voice of a little boy calling for his mother right behind him. When she turned around, the crying stopped, and there was no one there.

A woman's voice can be heard crying in the ladies' room on the ground floor, and the pressure in the room simultaneously drops, making it difficult to breathe. Wanting to be left alone, she often attempts to shoo away intruders by flushing all the toilets at once or slamming the stall doors.

Two people with an unknown story haunt room 505 and make guests feel uncomfortable in the space. It isn't uncommon for those guests to ask to change rooms in the middle of the night.

The staff of the Galvez isn't immune to having their own experiences. A hotel concierge once had a soft male voice whisper, "We like you" into her ear. Far from being unnerved, she was happy to hear of the spirits' approval.

Room 409 called the switchboard repeatedly one night, but no one would ever actually speak to the operator. When she filed her report with the front desk, the staff on duty replied that no one was registered in that room, so security was sent to investigate. Not only was there no one there, but also, due to ongoing renovations, the room had no furniture—or phone.

A staff repairman reported pulling the power cord out of the television in room 503 in order to fix it, and the set came on. Obviously an impossibility, he knew the hotel well enough not to second-guess the event. He quickly put the cord back together; called out, "Enjoy yourself!"; and left the room.

The beloved hotel is home to ghostly staff members as well. Guests can expect to see or even be assisted by phantom maids and bellhops. They were particularly active after Hurricane Ike, when many staffers stayed at the hotel while their own homes were being repaired.

Whether visiting Galveston to relax and be pampered or to explore the excitement of contact with the other side, the Hotel Galvez offers an ideal vacation spot.

19

OLEANDER HOTEL

POSTOFFICE AND TWENTY-FIFTH STREET

In the early days of Galveston tourism, the island was a mecca for the wealthy and sophisticated traveler. It was also alluring to those who were seeking rowdier styles of entertainment.

The building currently seen at this location has no resemblance to its original exterior from 1913. The downstairs area was composed of five different storefronts, with the Oleander Hotel upstairs. A central atrium provided natural light and circulation in the days before air conditioning.

By the 1930s, the Oleander had evolved into a brothel. It was a lucrative time to be in the prostitution business, and customers flocked to spend time with the girls and listen to "Blind Willie" play tunes on the piano.

Just as surrounding cities like Houston and Beaumont were determinedly shutting down their "restricted districts" filled with saloons and houses of ill repute, Galveston had a red-light district that was coming into full swing, covering twelve and a half blocks of the city. The most visited houses of prostitution lined the infamous Postoffice Street.

Today's visitors to the Oleander Hotel, now home to the Antiques Warehouse, can get a small glimpse into what life at one of the bustling brothels was like.

The upstairs is a maze of tiny bedrooms the size of walk-in closets, many of them decorated with beds and claustrophobically piled with other antiques for sale. Room numbers still hang below the original transom windows, and creaking floorboards add to the atmospheric eeriness.

A room in the former Oleander Hotel. *Author's collection.*

A penciled tally that the current owners believe was a prostitute's earnings is still visible on the wooden walls of one of the rooms.

Visitors with no knowledge of the background of the building, whose façade has been drastically altered, often ask the owner as they leave if he knows it is haunted. The answer is a definite, "Yes."

Especially strong energy seems to reside in one dark room that is blocked off from the public by a screen door and used for storage. A former kitchen, it reportedly doubled as a room where the brothel's doctor examined the girls. Many people feel it exudes a sense of fear and grief.

The owner of the shop himself has had the hair rise on his arms upon going upstairs and experienced uneasiness so strong he immediately retreated to the ground floor.

It's a great place to visit for anyone interested in shabby chic décor or otherworldly encounters.

20
ROSENBERG LIBRARY

2310 SEALY

Frank Chauncey Patten served as the head librarian for Rosenberg Library even before its doors officially opened to the public. From 1903 until his death in 1934, Patten worked tirelessly to establish one of the country's most respected libraries.

In 1921, the Texas Historical Society, formerly the Galveston Historical Society, appointed the Rosenberg Library as official custodian of its archives, transferring ownership to it in 1931. The bachelor librarian dedicated himself to cataloguing the collection and worked to obtain additional rare maps, books and relics to expand it.

But when he passed away in 1934 at seventy-eight years old, the process stopped with no one to continue the work with the same level of dedication. The treasures of his cherished collection were stored in the attic unattended. It was enough to make the devoted archivist turn in his grave.

Luckily for everyone, the archive was renamed the Galveston and Texas History Center in 1983 and moved onto the fourth floor of the Moody Memorial Wing. Patten would be pleased that the items he so dearly tended are now stored in climate-controlled conditions, attended by experts in the field and accessible to the public for enjoyment and research.

Another of Patten's special focuses was the children who visited his library. He personally chose each volume for their department and instituted a summer reading club when they were out of school, rewarding participants with handsome certificates.

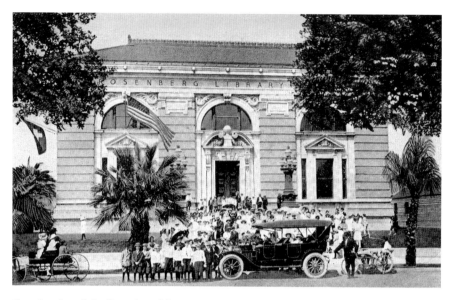

Opening day of the Rosenberg Library, 1904. *Author's collection.*

Rosenberg Library's
first librarian, Frank
Chauncey Patten.
*Courtesy of the Rosenberg
Library, Galveston, Texas.*

Children's librarians have been known to share the story that children who mistreat the books or handle them roughly at the Rosenberg sometimes receive a rap on the shoulder or head. It's up to the reader to decide if that particular tale is meant to warn or merely maintain order.

More often than not, the facility's budget in the early years was strained or nonexistent, and only Patten's dedication kept the programs and new book acquisitions available to the community. It's no wonder he would take offense if a youngster, or anyone else, mistreated the books.

Patten resided over the Rosenberg for thirty years. It was revealed after his death that he had secretly contributed $38,000 during his years as a librarian to ensure that assistant librarians would receive their paychecks during lean budget years. He also left most of this estate to the institution.

Custodial crews report hearing footsteps on the marble floors at night when they are sure they are alone. The sound is somehow more comforting than alarming, however, as if they are being kept company.

The light, ghostly laughter of children has also been heard on the stairs long after closing time, and unexplained steps and dragging noises come from the attic.

Visitors and employees have caught a passing glance of a gentleman in a suit walking the halls or descending the stairs, though a second glance reveals no one is there. Surely Patten is still keeping an eye on his beloved library, making sure that it is cared for and that its patrons are happy.

21
FIRE STATION NO. 6

3712 BROADWAY

O ne of the most friendly and playful spirits said to inhabit the island is
Captain Jack, who makes his presence known at the old Fire Station
No. 6.

While the building was still an active fire station, firemen experienced
sounds of movement in empty rooms, odd smells and an occasional object
moving locations.

But Jack seemed to have the most fun making himself known to rookies
of the department. He didn't particularly care for anyone sleeping on his
cot by the south window and would shake unsuspecting nappers awake if he
caught them there. He also made his presence known with footsteps going
up the stairs toward the sleeping quarters late at night.

Local amateur historian Jan Johnson theorizes that he's the spirit of
Captain John "Jack" Knust, who was a beloved member of the Galveston
Fire Department for thirty-eight years and active until his death in 1958.

A veteran of World War I, Jack was respected for his caring supervision of
the men with whom he worked.

Although the building was decommissioned and now serves as a
nondenominational church, it's said that the captain occasionally checks
in on the place where he spent so many hours, just to make sure things are
in order.

22

BISHOP'S PALACE

1402 BROADWAY

Undeniably the crown jewel of Galveston's architectural treasures, the Bishop's Palace is the most photographed landmark on the island.

Commissioned by Colonel Walter Gresham and designed by famed architect Nicholas Clayton, the castle was constructed between 1887 and 1892, with seemingly no expense spared.

Cited by the American Institute of Architects as one of the one hundred most important buildings in America, it features nine turrets, Romanesque and Tudor arches, Siena marble entrance columns, soaring stained-glass windows, decorative plaster ceilings and an array of the world's most exotic woods and stones.

If a visitor to Galveston has time to visit only one place, this should be the one.

Gresham's substantial home accomplished more than impressing Galvestonians, however. It also sheltered six hundred of them during the 1900 hurricane, when it had an almost clear view to the shore due to the number of obliterated homes.

After his death, Gresham's family sold the palace to the Catholic diocese, and it was renamed Bishop's Palace. Bishop Byrne lived there until his death in 1950.

The continuing efforts of the Galveston Historical Foundation ensure visitors will enjoy the building for generations to come.

Although its foreboding appearance seems a likely home for ghosts, it is more probable that sightings at the castle are "residual hauntings," a type

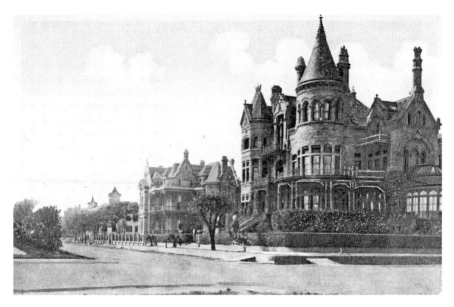

A postcard of the Gresham home, now known as Bishop's Palace, on Broadway Boulevard, circa 1900. *Courtesy of the Rosenberg Library, Galveston, Texas.*

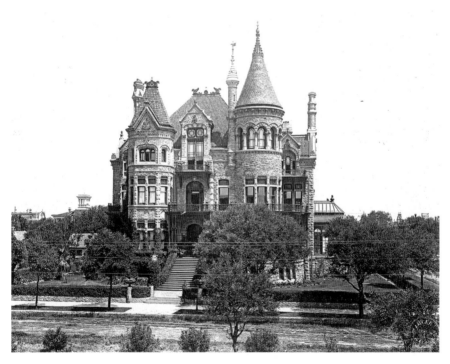

The Gresham home, prior to the 1900 storm and grade raising. *Courtesy of the Rosenberg Library, Galveston, Texas.*

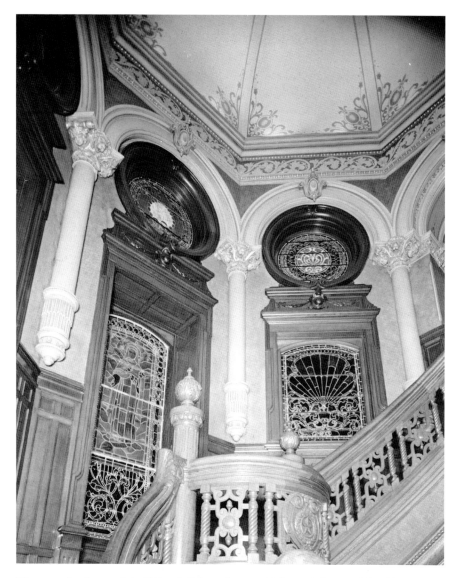

The central staircase of the Bishop's Palace. *Courtesy of Library of Congress, Prints & Photographs Division, HABS.*

of energy impression from another time. Those who lived their lives in the home have surely moved on to their next adventure, having experienced so many wonderful things here.

The most common sighting is that of Colonel Gresham, who appears to pace back and forth on the porch, walk around the grounds inspecting the

home and finally disappear inside. It is said that he appears when a storm is coming to ensure the safety of his home, as he did before the 1900 storm.

Josephine Gresham, the lady of the home, was a talented artist, exemplary hostess and an avid traveler. Throughout her extensive travels, she mailed souvenir postcards home for her collection that were kept and displayed in a large ornate box still on view in the home. The box is rumored to move locations randomly, which would be quite a feat considering its size and weight. Perhaps her spirit is reenacting showing her prized collection to visitors.

An apparition of an elegant woman ascending the famous octagonal, mahogany staircase might also be Josephine's image, echoing a motion she repeated for so many years.

Other spirits or visions have been sighted through the years, usually of servants who worked for the Gresham family at one time going about their daily tasks. The fact that they seem unaware of strangers in the home supports the theory that their presence is only a reflection of past events.

23

ASHTON VILLA

2328 BROADWAY

Strikingly different than most of the other historic homes on Broadway, the Italianate mansion named Ashton Villa was built in 1859 by wealthy businessman James Moreau Brown. The stately, three-story building with cast-iron galleries was one of the first brick houses in Texas and the setting of some of Galveston's most lavish parties and social gatherings.

At one point during the Civil War, after Mr. Brown had sent his wife and children off the island, the opulent home was used as a Confederate hospital during a deadly outbreak of yellow fever. The amount of pain and death experienced in the home during that short time alone makes it a likely place for lost souls.

Once the family returned and the city had brushed off the misery of war, the Brown home returned to being a place of socialization and joy.

Of the Browns' five children, two sisters are the most famous.

Rebecca, or Bettie, a shockingly independent artist, socialite and lifelong bachelorette, traveled the world. Considered quite scandalous in her day, she smoked cigars, painted risqué paintings and drove her automobile through the Galveston streets with abandon. Any other woman who behaved this way at the time might have been shunned, but Bettie was well loved by the community, perhaps in part for her outrageous behavior.

Her demure younger sister, Mathilda (or "Tillie"), was quite the opposite of Bettie in character. She was encouraged by her father to marry a local businessman at the tender age of nineteen. Mr. Brown built Tillie and her

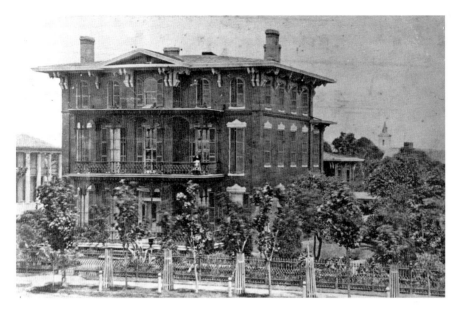

Ashton Villa, prior to the Civil War. *Courtesy of the Rosenberg Library, Galveston, Texas.*

husband, Thomas Sweeney, a home of their own, now named the Sweeney-Royston House, where they had three children together.

Sadly, the marriage was an abusive one, and Thomas's drunken rages were well known among family, friends, neighbors and servants. There were times when his rages were so violent that his own children would scatter and hide when he returned home.

After her father's death in 1895, Bettie rallied behind her sister by collecting affidavits of her brother-in-law's behavior from witnesses, helping Mathilda to obtain a divorce. Tillie and her children moved into Ashton Villa never to return to their former home.

The young mother must have been relieved to settle herself and her children back into the gracious life she had previously known, co-hosting parties and doing philanthropic work with her mother and sister.

Ashton Villa survived the 1900 storm thanks to Mrs. Brown's orders to open all of the doors and windows, which allowed the surging waters to rush through rather than knock the home off its foundation. In the days that followed, the walls gave shelter to many victims, and Bettie and Tillie worked tirelessly to distribute food and supplies.

The city mourned the loss of its dear Miss Bettie in 1920, when she died of Lou Gehrig's disease in her bedroom. Her parents had also both died in the home.

Mathilda lived her final days with her daughter in Louisiana, after Ashton Villa was sold to the El Mina Shriners in 1923.

The property was once again sold in 1968, falling into disrepair before the Galveston Historical Foundation purchased and restored the mansion.

Though physically gone, many people believe that presences from earlier days remain in the home.

During the years that the Shriners occupied the home, many of its original furnishings were there, including Bettie's wooden coffer chest. The box where Bettie kept souvenirs from her travels befuddled the Shriners, as it had a habit of locking and unlocking by itself. This happened despite the fact that the key to the chest had reportedly been misplaced years beforehand.

A portrait of Mathilda "Tillie" Brown Sweeney. *Courtesy of Trish Clason.*

Piano music has been heard drifting from the ornate formal living room, known as the Gold Room, where many of the family parties were held. Once the music was so audible that it awoke a caretaker and his dogs. Because Mathilda was an accomplished pianist, many believe it is her spirit they see sitting at the instrument before slowly fading away. She doesn't seem to mind that the piano now in the home is a replacement to her original.

The formal dining room no longer contains furniture but echoes with the ghostly sounds of guests' soupspoons clinking bowls, especially at Christmastime.

When Ashton Villa was a house museum, numerous docents bemoaned the fact that it was impossible to keep the rose-colored bedspread on Miss Bettie's bed neat. They would tidy it between each tour only to find it rumpled several minutes later.

The spirit of a woman in a turquoise Victorian dress has been spotted on the grand stairway and in the hallway of the second floor and is often mistaken for a docent or tour guide. Her appearance is followed by the scent of jasmine. She is said to bear resemblance to photos of Bettie, who wore the same perfume and favored the color blue.

After Hurricane Ike, when docents were moving boxes back into the home, one lady saw a female come up the stairs to the second floor and

Brown family dinner party at Ashton Villa. *Courtesy of Trish Clason.*

pass through the hallway. Assuming it was her co-worker, she called her name only to find she was coming up the stairs an entire flight behind the specter. Unnerved, the woman immediately declared an end to her shift.

A well-known psychic recently felt the presence of a man pacing from room to room on the second floor and detected a strong feeling of anxiousness. Could it be that a doctor is still tending his Confederate soldier patients?

There are also reports of ghosts in the home wearing clothing styles from the early twentieth century, clocks stopping and the sound of furniture moving in the third-floor boys' dormitory. Though a bit more difficult to explain, they are no less real to those who experience them.

Perhaps Mathilda's spirit has remained where it felt safest in life, and Miss Bettie's feisty presence wants it known she is still in control. Or it might be that the personalities and emotions that were so strong during their lifetimes left an impression of sorts in the home where they created so many happy memories.

Although Ashton Villa hasn't been open for regular tours since Hurricane Ike in 2008, the historic home is opened for specialty programming during Galveston Historical Foundation–hosted events and is available for private parties and receptions.

24
VAN ALSTYNE HOUSE

2901 BROADWAY

Alfred Albert Van Alstyne and his wife, Catherine, built this Victorian beauty on the corner of Broadway and Twenty-Ninth Street in 1891.

The son of one of Houston's most prosperous businessmen, Albert moved to Galveston to begin a steamship line operating between Galveston and Velasco. In later years, he managed the National Cotton Oil Company.

Catherine was successful as well, garnering fame as a talented singer. Galveston took great pride when she toured Europe, receiving glowing reviews. She was a popular soloist at local Saengerfest concerts.

As fragile as the home appears, with its delicate gingerbread trim, it survived the hurricane of 1900, saving the lives of family and friends who found shelter under its roof. At the time, Albert lived there with Catherine; their daughters, Mary and Alberta; his mother-in-law, Mary; his brother-in-law, Walter Lufkin; and a servant named Lillie.

A letter written by Catherine and found years later on the premises bids its recipient to "imagine 50 of us huddled under the stairs."

After the storm, because they had a large supply of provisions, such as rice and canned goods, the couple used their home as a base of supplies for the needy in their neighborhood. Shadowy figures seen wandering the grounds outside the home are most likely the shadows of distraught Galvestonians who know this is as a place of refuge.

Albert and Catherine both died in their home, he in 1926 and she in 1940. They are buried in Trinity Episcopal Cemetery just a few blocks from their home.

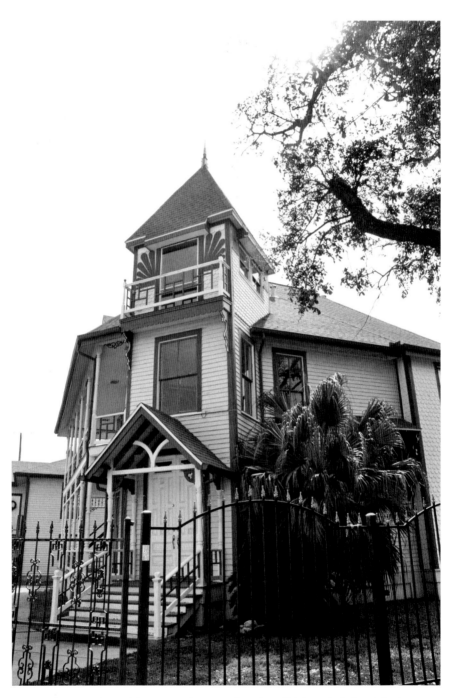

Victorian-era beauty, the Van Alstyne home on Broadway Boulevard. *Author's collection.*

At one point in time, the large home served as a youth shelter for boys, housing a rotating population of children in need. Former residents during this period claim to have seen the ghost of a man in the attic. The spirit never spoke but always succeeded in frightening the youths back to the dormitory floors.

One boy told the story of going up to the attic to retrieve a board game and suddenly feeling as if he were being watched. Upon turning around, he saw a man in a Victorian suit staring at him from outside the window. It didn't occur to the youngster until after he had fled downstairs to his friends that there is no landing to stand on outside that window. He never went back up the stairs.

A series of antique co-op stores, including the Gingerbread House Antiques and Annabelle's Antiques, operated in the building in the years that followed. These merchants had their own unique set of experiences.

The tower attic had been destroyed during the hurricane of 1943 and was restored in 1991. Mysteriously, the door to the area was walled off when Annabelle's moved in.

Once the wall was removed, the door would slam shut by itself and visitors heard dragging noises coming from the attic.

It's difficult to say if the resident spirits approved of the home becoming a retail space.

The home's security alarm went off with such frequency that the police became accustomed to it. One young investigating officer who was responding to the home alarm for the first time felt the need to purchase a small crucifix from one of the vendor tables after hearing unexplained noises that his partner told him were common to the upstairs area.

Toys made sounds without being wound, and once an entire display table was overturned on the second floor when no person was nearby.

Strangest of all may be the group of ghosts that speak to one another with heavy European accents in the attic. The Van Alstyne family had been Americans for several generations.

Children who visit the home occasionally can sense the presence of other children as well, all of whom seem happy and playful.

One paranormal investigator claims to have captured electronic voice phenomena during a recording session at the home. He reported that the original owner of the home held a woman captive in the attic and that menacing voices threatened him during his visit. As he is the only person, including residents of the home, to have reported such information, it needs to be taken with a grain of salt. Absolutely no proof exists that anyone was ever imprisoned in the space.

The historic Van Alstyne home has been restored to a single-family dwelling and is waiting for its next chapter to be written.

25
BOLIVAR LIGHTHOUSE

419 EVERETT LANE, BOLIVAR

The first lighthouse in Texas was built at Bolivar Point in 1852. Scavenged for materials during the Civil War, it was rebuilt in 1872 as a 116-foot tower of iron, brick and plaster sturdy enough to guard the coast and its inhabitants for generations.

During the hurricanes of 1900 and 1915, the beacon of hope did more than assist ships offshore; it saved lives in its own community.

Early on the afternoon of September 8, 1900, a train from the Gulf and Interstate Railway from Beaumont passed the lighthouse on its way to a ferry landing, where passengers expected to board a boat and go into Galveston. As the train approached, it became apparent that the ferry had ceased running late that morning due to rising water. Attempting to reverse, the engineer found that the tracks behind them had also been covered by floodwaters. They were stranded in the largest storm to ever hit the coast.

As the water crept higher, entering the cars and rising to the level of the seats, a small, brave group of nine passengers made the decision to wade to the safety of the lighthouse. They reached it just before the water level made the doorway inaccessible. It would eventually be submerged beneath as much as thirty feet of floodwaters.

Along with residents of the island who reached the lighthouse, this handful of train passengers became part of the 125 refugees who spent the next fifty hours inside its protective walls.

The light keeper Harry C. Claiborne; his wife, Virginia; and their two small daughters had been the first inside, making sure the lamp had enough fuel to shed light into the coming storm.

Crowded in the pitch-blackness of the tower, the refugees sat on the stair steps, moving upward as the water rose inside. The fierce hurricane winds shook the tower, making it impossible to stand. The swaying also disabled the machinery of the light, but the lighthouse keeper and his wife heroically continued to operate it by hand.

Survivors emerged to find the area around their refuge littered with the bodies of animals as well as dozens of people who had tried to reach the lighthouse. In all likelihood, they were all buried on the grounds in the days that followed.

Having just purchased a month's worth of food, Harry and Virginia were able to feed people for several days before their supply ran out.

All eighty-two passengers who remained on the train perished as it was swept from the tracks.

The next big storm hit the area in 1915, and with the tragedy of 1900 still fresh in citizens' minds, no chances were taken. An estimated sixty people found safety in the lighthouse and rode out the storm huddled on its iron stairs. The keeper's wife recounted later that the man sitting on the bottom step began to curse violently as water crept beneath the door, but all inside were safe.

A catastrophe of a different kind assaulted Bolivar and Galveston later that same year when a horrific flu epidemic claimed many victims.

In the late fall of 1915, John Martin Gardner was working as a lighthouse guard during World War I and had his family with him. His thirty-two-year-old wife, Nora, pregnant with their second child, contracted the flu and became extremely ill. On the morning of December 5, the brave mother gave birth to a son, but she and the child perished the same day. They are buried in unmarked graves on the grounds of the lighthouse.

The permanent closure of the Bolivar Lighthouse in 1933 did not end its lifesaving duty.

In a July 1934 storm, another one hundred people took shelter in the lighthouse when Bolivar was completely cut off from the island by high water.

While the movie *My Sweet Charlie* was filming at the light keeper's house in 1970, actors Patty Duke Aston and Al Freeman Jr. were rumored to have seen a male ghost wandering the grounds.

There are also reports of a small boy who peers into windows and the sound of faint crying in the night.

There is a grisly tale that is popularly told about the son of one of the lighthouse keepers who murdered his parents in their beds, but no evidence that anything of this nature ever happened in Bolivar exists.

Most believe that the ghost of the man is Harry Claiborne, still manning the light out of a sense of devotion and perhaps to guide the other souls lost in the storms to safety.

26

JAMES J. DAVIS HOUSE

1915 SEALY

Recently known as the Queen Anne B&B, this 1905 home was designed by George B. Stowe for James and Emma Davis and their three daughters. The original stained-glass windows, pocket doors and inlaid wood floors make it a true island treasure.

James died of a stroke in 1922, and two years later, his wife sold the home to the First Methodist Church, which used it as an elders home for over twenty years.

In 1945, another Emma, this one a widow with five children, purchased the home and occasionally rented out rooms. She lived there until her death in 1988 at one hundred years old. The sound of a heavy rocking chair creaking against the floorboards is heard coming from her room.

The house sat vacant for two years before being purchased to use as a bed-and-breakfast. It is now privately owned.

The spirit of a tall, slender man is often seen in the home, comfortably wandering and observing the new occupants. He seems especially interested in gadgets and technology, going to far as to lean over the shoulders of people typing on computers to observe the modern-day devices.

He may also be the shadowy figure that has been seen in the hallways, and he was once noticed by an owner passing through a closet into the next room.

A cleaning lady shared that she saw the man's shadow walking from one room to the next before disappearing down a hallway several times.

One ghost that remains in the home sometimes shocks kitchen staff by loudly fumbling in the butler's pantry. After the noise ceases, nothing is found out of place.

On a number of occasions, workmen upstairs have heard someone walking down the stairs, open and close a door and continue walking. They were never able to identify the sound's source.

Footsteps can also be heard crossing the downstairs entry floor in the early morning hours.

A male occupant of the home discovered a photo of a previous owner and was shocked to see their resemblance. Upon showing the photo to family members, they confirmed he looked identical to the man in the print. He was left to ponder whether it was just a strange coincidence or something more.

During dinner one night, a group of people watched as a brass ring shot off a candleholder and landed on the table. It had been securely fitted to the top of the holder just minutes before. Perhaps the dinner conversation didn't meet the spirit's approval.

One former resident made her regular rounds one night ensuring that the upstairs lights had been turned off and the attic door was securely closed. She heard footsteps upstairs after going to bed but went to sleep regardless of the mystery. When she checked upstairs in the morning, the surprised owner found the attic wide open and a round, reddish spot the size of a dinner plate on the carpet at the top of the stairs. After she scrubbed it thoroughly, the stain was removed, but no one could ever figure out what it was.

With so many former tenants, it is hard to identify which spirits still remain, but because they are friendly, no one seems to mind them.

27

THE 1894 OPERA HOUSE

2020 POSTOFFICE ROAD

Irish actor Charles Francis Coghlan was one of the most respected Shakespearean stage performers and playwrights of his time.

In the fall of 1899, he and his daughter Gertrude were on tour in a production of *The Royal Box*, Coghlan's adaptation of Alexandre Dumas's play, and scheduled to perform at the opera house in Galveston. Almost immediately upon arriving in the city, however, he became quite ill and was confined to his room at the old Tremont Hotel.

The company went on to perform the play in Galveston and San Antonio, receiving glowing reviews about Coghlan's brilliant performance. What no one seemed to realize was that it was his understudy in the role, as he was still too ill to perform.

On November 27, he died in Galveston with his wife, who had come to care for him, by his side. The newspaper reports shocked the public, many of whom were still under the impression they had recently seen him perform.

Coghlan had made his wishes to be cremated known, but the nearest crematorium at the time was in St. Louis. In order to give the widow time to make arrangements for the transportation of his body to Missouri, he was placed in a specially ordered metal coffin in a receiving vault at Lakeview Cemetery.

Before any plans were finalized, Coghlan's friends and admirers in New York protested, requesting that he be sent there. Overwhelmed, his wife returned home to let them handle the change of plans.

Hotel Grand, part of the Grand 1894 Opera House, circa 1894. *Courtesy of the Rosenberg Library, Galveston, Texas.*

In the confusion, Coghlan's remains lay in the vault for almost a full year, until the hurricane of 1900 hit the island. His heavy coffin was swept from the vault and never recovered. The request for the transfer of his body had finally arrived just days before the storm.

The local undertaker at Levy Brothers said he could identify the casket if it was ever found, as it was the only one of its kind in the state at the time, but he never had the chance.

Decades later, a story in *Ripley's Believe It or Not!* began the legend that in the course of a year, the coffin had floated all the way to Coghlan's summer home on Prince Edward Island, where he had been buried in a touching ceremony.

It was a great tale, but it just isn't true. No one may ever know what happened to the great thespian's remains, but he does occasionally make special guest appearances at the Grand. Encounters with his ghost have been reported several times by opera house employees and actors.

Some have reported a male apparition, assumed to be Coghlan, watching performances from the wings. Others say they have seen his hazy apparition floating down the outer aisle or sitting in the second-tier balcony.

In true, dramatic style he is described as wearing a hat and cape.

Because he was cheated out of performing at the magnificent theater, perhaps he is waiting for another chance. Or it might be that he is offended that an actor of less importance was mistaken for him.

Whatever the case, he seems to be patiently waiting and watching, staying near the theaters where he thrived during life.

28
Isaac Heffron House

1509 POSTOFFICE

Isaac Heffron lived in this home with his wife, Clothilde; their son, William; and three daughters: Clothilde Elizabeth, Laura and Norine.

Heffron's name might not be as familiar as others from Galveston history, but he instituted changes that had major effects on the daily lives of the city's health and prosperity. A wealthy concrete manufacturer, he cleverly used his product and its benefits in ways never previously devised.

After an epidemic of diphtheria on the island, Heffron proposed and built Galveston's first sewage system. Before his system was installed, the waste from privy houses was gathered in barrels and dumped into the bay. He was also on the forefront of the effort to ensure a dependable supply of fresh water for residents.

In 1893, Heffron improved on the sewage system when he developed and patented a design for a sewer trap to prevent grease and other matter from sinks and bathtubs from lodging in the sewer. The invention allowed sewers to operate with less maintenance and made them less likely to harbor disease.

The ingenious businessman was also awarded the city contract to furnish 4,400 cubic yards of broken stone and one thousand tons of riprap in 1907 for the seawall project.

A unique exterior feature of Heffron's 1890 home on Postoffice Street reflects his career with concrete as well: an ornate concrete balustrade that lines the front sidewalk.

Later owners of the home included Thomas Jefferson Holbrook, who served as Galveston's state senator from 1922 to 1939, and pharmacist Edmund J. Cordray, who utilized it as part of a family compound.

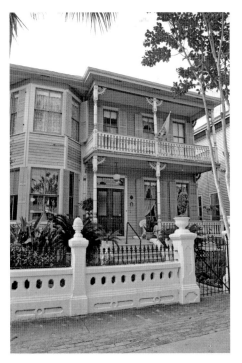

Isaac Heffron House. *Author's collection.*

Two bullet holes in a transom leading from the butler's pantry to the side porch remain a mystery. They might be connected to meetings of the Sons of the American Revolution, during which members startled neighbors by spending the evening firing guns from the upper balconies.

A ghost that one owner called Norma Jean, after the famous blonde, resides in the house, but no one has unraveled her true identity. She occasionally makes herself known by creating strange noises or turning over tabletop items. She is also credited with making a pet bird's water bowl disappear, which was probably less appreciated by the bird than the owners.

Whispers and footsteps are gentle reminders of her presence. None of the ghost's mischief is harmful, but it's best to acknowledge that it is her home as well.

Galvestonians are fairly certain that the spirits in this house don't belong to the Heffron family since they make their presence known at one of their later homes. (We'll find out more about this in Chapter 31.)

If you stroll in front of the home, be sure to look down for a delightful surprise. When the sidewalk was replaced, a recent homeowner imbedded it with doubloons from Mardi Gras, glass marbles, old keys and other surprises. It's an interesting use of concrete that would make the original owner proud.

29
"OLD BILLY"

1517 POSTOFFICE

Robert T. Bilderback, known around town as "Old Billy," lived in a house that straddled this and a neighboring lot. Seen and felt in both current homes, his spirit seems to manifest at 1517 Postoffice Street most regularly.

A shoemaker by trade, he arrived in Galveston aboard a ship named *McKim* in 1845. He kept to himself, never marrying or making friends, and was extremely secretive about his actual age.

In 1861, Bilderback was tried by a Confederate military tribunal and sent to prison in Huntsville for being a vocal Unionist. He remained there until the end of the war. The experience did not endear the community to Billy or vice versa.

He had a reputation for being exceedingly thrifty, even going so far as to bury his money in jars around his property. Billy kept working until his death from tetanus in 1883 at the assumed age of ninety-eight.

The loner was discussed more in the local newspapers after his death than during his trial due to the nature of his will. Having no relatives, Billy left the entirety of his estate to the Universalist General Convention (now known as the Universalist Church of America), with which he had become affiliated before moving to the island. Obeying his instructions, his executor followed explicit instructions to retrieve all the hidden jars of savings from Billy's property.

Initially thought to be an impressive sum of $10,000, the will was heavily contested by several parties for months. The actual amount of $7,500 was eventually awarded to the church.

1517 Postoffice Street. *Author's collection.*

Understandably, the fact the Galvestonians took more interest in him after he was dead has not set well with Billy's ghost. He still prefers not to be disturbed and finds solace in hiding in a closet beneath the staircase of the present home.

When he does emerge from the refuge, dogs have been alerted to the presence and moved their heads, tracking something invisible. It's no wonder that houseguests can feel uneasy.

A housekeeper has repeatedly witnessed a shadow figure traveling from the closet area to the dining room, and residents have clearly heard the front door open and close only to investigate and find it locked.

One homeowner set a bag full of books just outside the closet and later found the contents flung across the floor when she returned.

A male voice has been heard calling the homeowner's name when he was alone, and although the resident always latches the pantry door securely at night, it is often open by morning.

A scruffy-looking gray-haired man wearing a cap and thought to be Billy has peered in kitchen at the homeowner through the transom or the back window, scowling before fading away.

Even though "Old Billy" doesn't seem to approve of the newcomers, he never causes any harm.

30

MOLLIE WALTER'S BORDELLO

2528 POSTOFFICE

Mollie Walters may have been young at only twenty-five years old when she came to Galveston from New Orleans in 1868, but she knew what customers wanted.

Galveston was a thriving port city, and sailors, soldiers and wealthy businessmen were always looking for a good time. The red-light district was centered on Postoffice Street and at one time had as many as thirty brothels, also known as "sporting houses."

Mollie built her two-story, wood-frame "female boarding house" on the northwest corner of Postoffice and Twenty-Fifth Street, with doors on both streets and the alley in 1886. The latticework surrounding the front door, long gone, allowed the more discreet customers a bit of privacy.

Catering to the wealthiest clients on Postoffice, Miss Mollie's offered live music, elegantly dressed hostesses and a bar, and she soon became the most profitable madam in the city. Spending the night with one of Miss Mollie's ladies could cost a man $300, an entertainment that only white-collar customers might consider.

Mollie's private parlor featured a secret door for special clientele that led directly to her chamber.

When business was slow, the women would sit in the windows and call to men passing on the street.

Occasionally, the local police would makes the rounds, arresting the madams, more to appease the community than to keep the law. The ladies paid their fines and were released in time for the evening business hours.

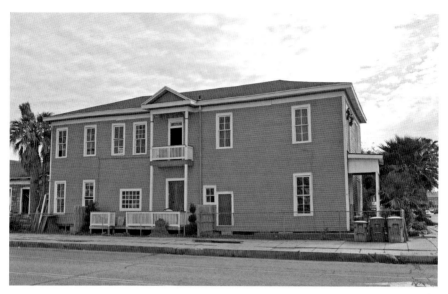

Above: The only surviving brothel building on Postoffice Street. *Author's collection.*

Left: The front door of Mollie Walter's bawdy house. *Author's collection.*

Mollie continued running the business until she retired in 1906, when she leased the operation to Corinne Pearce, who gave the establishment the name "The Club."

During her years as the resident madam, Pearce was charged with the murder of a client with whom she had had a disagreement. After a short trial, she was acquitted and returned to business as usual.

The most famous of the madams to run this location took over the bordello in 1918. Hazel Harvey, known as "Mother Harvey" because she was kind to children, brought the bawdy house back to the standards of Mollie's days, becoming increasingly busy as Prohibition took hold of the state. She sold bootleg whiskey to the clients, and her girls drank watered-down spirits while keeping them company.

An insurance man who was well respected in Galveston used to stop by Mother Harvey's place each morning to have coffee with the ladies, parking his car in the alley. Tragically, he suffered a heart attack and died at the kitchen table on his last visit. Mother Harvey called her good friend in the police department, and they came up with a plan to save to man's good name and protect his family from any embarrassment.

They loaded his body into the trunk of a car and drove him to Kempner Park. There they staged the body on a bench as if he had peacefully passed away while feeding the pigeons.

There were just a couple details that the pair missed, however, and the ghost of the insurance man is still at the bordello searching for his hat and keys.

"Gouch-Eye" Mary Known was the last madam at the house, running it until it closed in the early 1950s, when open prostitution became a thing of the past.

Witnesses swear they've seen spirits of the working girls in the windows and of men walking along Postoffice Street at dusk. Perhaps one of them will take mercy on the insurance man and help him find his hat and keys.

31
VICTORIAN INN

511 SEVENTEENTH STREET

After becoming prominent in the city, Isaac Heffron moved his family from 1509 Postoffice to a grander residence that was more fitting for their social position.

Construction on the new home began in 1899 under the direction of Charles W. Bulger, a noted Galveston architect. Just months into the project, the 1900 storm hit the island, leveling a great number of buildings. Luckily for the Heffron family, the home had not been damaged beyond repair, and they moved in at the beginning of the following year.

Heffron made his fortune in concrete and built his home of it as well. Shelled with a distinctive red brick veneer, the home is known for its beauty as well as resembling a steamboat from a distance. It was oriented facing Seventeenth Street to take full advantage of the gulf breezes.

The family, which included one son and three daughters, happily lived in the grand house for forty-three years. It was the site of many of the festivities surrounding the marriage of the eldest daughter, Clothilde Elizabeth, to Andrew Falligant in 1904.

Both Isaac and his wife, Clothilde, died at home, he in 1928 and she in 1943. Their funerals were held there, as well.

Now known as the Victorian Inn, the home is enjoyed by hundreds of guests annually. Its charming innkeeper goes to great lengths to make each guest's stay memorable. In addition to the exquisite surroundings, she ensures there are elegant meals and has even established a bunny sanctuary beside the backyard sitting area.

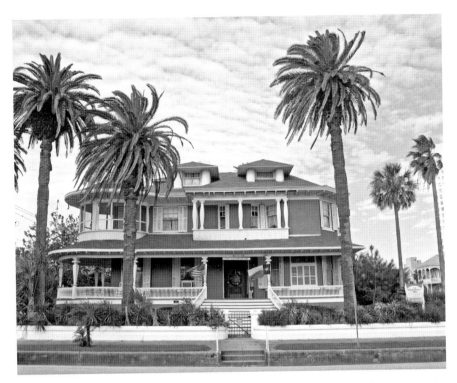

The inviting Victorian Inn. *Author's collection.*

One pair of guests, however, complained about everything during their stay. During breakfast the following morning, a pin flew out of the kitchen door hinge and hit the male guest squarely on the back of the head. Clothilde, who received her education at the Ursiline Academy and Mrs. Brown's School for Girls, obviously won't abide bad manners in her home.

Several sightings of the ghosts of the Heffrons have taken place over the years; they seem content to remain in their beloved home.

The Heffrons also seem to help take care of things around the home, as proven by a clock that winds itself, back porch lights that turn on by themselves and lights flickering to announce the arrival of guests.

Clothilde has been seen on the front porch, as well as wearing a nightgown by the butler's pantry.

The apparition of a little old lady, smiling peacefully, sits in front of the fireplace, exuding a feeling of joy. A man has also been heard whistling and felt touching shoulders reassuringly in the living area.

A golf club inscribed with the date 1899 once appeared and was attributed to Isaac, who was a member of the Galveston Country Club that year.

Between two and three o'clock in the morning, the spirit of Mr. Heffron sometimes walks out to the balcony off the master bedroom, now known as Mauncey's Suite. Witnesses have also seen him in the attic and walking across the front porch.

Footsteps are heard in what was once the eldest daughter's room, and in Zacary's Suite on the third floor, a woman hums happily.

Regardless of the fact they are no longer alive, the Heffrons certainly appear to be some of the most inviting hosts on the island.

32

ALFRED NEWSON HOUSE

1801 BALL

B uilt in High Queen Anne style in 1896, the Newson House is easily distinguished by its corner entrance at the top of a tall, inviting flight of steps.

Alfred Stroman Newson and his wife, Margaret, lived in the home with their daughter, Musette, whose husband, George Black Ketchum, moved in with the family after they were married in 1902.

Just two years earlier, the small family and their servant, Albert Carter, had survived the Great Storm of 1900.

Albert was the proprietor of the Model Meat Market on Mechanic Street and well respected in the community. He later formed a partnership with Louis E. Gottheil and purchased a steamer named *Charlotte M. Allen,* which plied trade between Galveston and Bolivar, providing fresh meat from his butcher shop.

Later in life, the astute businessman was also a partner in the G.B. Marsans Company, as well as a director of the Galveston Building and Loan Company.

After Alfred led such a productive life, his wife was devastated when he began to suffer from dementia. She bravely filed to be his guardian and tied up the loose ends of his business just months before he died in 1915.

The most unusual aspect of the haunting at 1801 Ball Street is that the most persistent spirits are ghost cats.

Several former owners have noticed strange cats from the corner of their eyes, only to find nothing there when they turn to see the mysterious creatures. This has happened inside the home and in the yard.

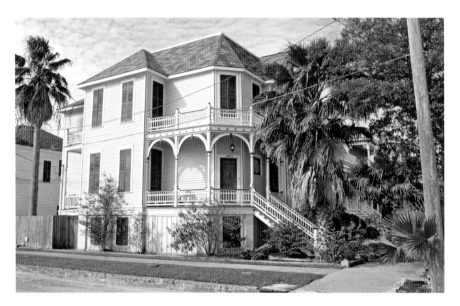

The Alfred Newson Home. *Author's collection.*

One woman who lived in the home found her cat behind the closed door of an upper room and the back of the house, which she hadn't entered in quite a while. The feline seemed quite content to be there and hadn't so much as meowed to be released. A neighbor later told the woman that a former boarder in that room enjoyed the company of cats and had several of his own. Could it be possible that her cat was enjoying the attention of a ghost?

The same female owner, who lived in the home alone, was locked in her bedroom with her dog and cat one night when she heard a loud crash from downstairs. When she went to investigate, she found that a board game left in the center of the coffee table had been flipped onto the floor. Police responding to the call found that a neighbor reported he had seen a possible burglar looking through the home's window. The would-be intruder had become so frightened by something he saw that he ran before causing any damage. It seems that the protective spirit will resort to shocking tactics in order to protect the home and its residents.

Another sign the spirit or spirits can be helpful occurred when a gentleman complained that several items belonging to him had either been misplaced or disappeared. He asked aloud that the items be returned and later found them in the center of the guest room bed.

Most people would enjoy having loving animals that need no care and increased sense of security in their home. With this house, it's a package deal.

33

CHARLES ADAMS HOME

2314 AVENUE M

This pre–Civil War home, built in 1860, looks every bit the part of a gracious southern manor and is listed on the National Register of Historic Places. The Greek Revival–design home was built by a wealthy merchant named Charles Adams.

The 1860 home survived the hurricane of 1900, unlike two family members, son Toby Adams and his wife, Jessica. Their bodies were found among the storm debris five days later.

In 1921, the home was turned from the original facing of Twenty-Third Street to Avenue M to avoid exposure to increasing commercial traffic.

At one time, Mrs. Franklin operated a boardinghouse at the home and came to be known to her tenants as Mother Franklin. One day, just months after she retired in the early 1980s, she walked from her retirement home back to see the house one more time, went home to make her own funeral arrangements and passed away within hours.

While she was running the boardinghouse, Mother Franklin was quite particular that everything be kept in order, but her spirit wants to ensure that no one else will quite be able to live up to her reputation. After thorough cleanings, recent owners have found sand scattered on the floor and bed covers in disarray. Items tend to disappear briefly and reappear in other rooms, as well.

One of Mother Franklin's boarders was Anna Kinkler, a woman who lived there with her daughter, Hedwig, and died in the home in 1938 at the age of sixty-five. Multiple witnesses claim to have seen her ghost in the form

The antebellum home of Charles Adams. *Author's collection.*

of an elderly woman in a black taffeta skirt and wearing her hair in a bun. It's possible she didn't want to leave her daughter alone.

One of the resident entities might be the ghost of a man who committed suicide in the home in 1956. He has discovered how to enjoy himself in the afterlife. This mischievous presence enjoys hiding shoes or clothing items, which are eventually located in unusual spots.

A Russian sailor named Zoey rented the carriage house at the property and eventually became a handyman for Mother Franklin. His spirit manifests itself in a more dramatic fashion than the others—by levitating various objects around the home. The spirit also seems to have an affinity for toothbrushes; if he is displeased with someone, his or hers might end up in the toilet!

The house underwent extensive restoration before becoming home to the Rose Hall Bed and Breakfast.

Rooms at the inn featured journals for guests to reflect on their thoughts about the home and often included comments about ghostly encounters with up to five different spirits.

Among guests' favorite experiences were visits by a charming ghost dog that woke people by licking their faces or hands.

Footsteps are also heard throughout the home but especially seem to center at the backdoor. No source for the sounds has ever been discovered.

34
ASSORTED GHOSTLY ENCOUNTERS

SKINNER HOUSE

1318 Sealy

Banker William Cooke Skinner and his wife, Adele Skinner, were the original owners of this gable-front, Queen Anne–style house, built in 1895. The iron fencing is original to the home.

Residents, including children, through the years have seen a man in a white suit and hat on the stairway, but if he can interact with the living, he chooses not to do so. Hazy apparitions and strange noises have also occurred throughout the home.

One owner reports that he heard a dragging and thumping noise coming from the attic for an extended period one night. When he went to the attic to investigate, he found a cane they had never seen before lying on a stack of books that the family had stored there. The top was engraved "J.D. Skinner, Nov. 6, 1895."

The home of William Cooke Skinner. *Author's collection.*

SEALY MANSION

2419 Sealy

Known as "Open Gates," the magnificent twenty-four-thousand-square-foot home of George and Magnolia Willis Sealy was designed by the famed architect Stanford White in 1889. Normally the site of lavish balls and social occasions, it served as a temporary shelter for four hundred victims of the 1900 storm.

The home currently belongs to the University of Texas Medical Branch and retains many of the furnishings original to the home. It is used as a conference facility.

A woman in a gray uniform that walks serenely up the stairs and visits each room is the most commonly seen spirit in the home. She was once attributed to be the family's aunt Agnes, but her clothing doesn't align with Agnes's more resplendent wardrobe.

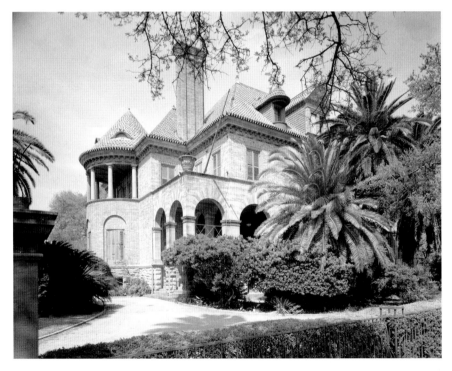

The George Sealy mansion, known as Open Gates, which now serves as a conference center for the University of Texas Medical Branch. *Courtesy of Library of Congress, Prints & Photographs Division, HABS.*

The Sealy mansion sitting room, circa 1910. *Courtesy of the Rosenberg Library, Galveston Texas.*

She is more likely to be the ghost of Hannah Sullivan, an Irish servant who came to work for the family as a teenager in the position of housekeeper and nanny. Hannah worked in the beautiful home for years before marrying and moving away to New York, but newspaper accounts report that she came back to visit.

It seems understandable to want to return to such a lovely home before and after death.

USS CAVALLA

Sea Wolf Park, Pelican Island

Family-friendly Sea Wolf Park is a great place to get an up-close look at a real piece of history. It is home to the World War II USS *Cavalla*, the only submarine to sink one of the aircraft carriers responsible for the attack at Pearl Harbor, and the USS *Stewart*, one of only three destroyer escorts in the world. Both are permanently on exhibit and can be boarded and toured.

The quarantine station at Immigration Station No. 2. *Courtesy of the Rosenberg Library, Galveston Texas.*

Affectionately called the Leap Year Lady, the *Cavalla* was commissioned on February 29, 1944, and sunk the aircraft carrier *Shokaku*, as well as two freighters and a destroyer during the war.

Paranormal groups have investigated both craft and heard unexplained pinging, voices and mechanical sounds, as well as those of shuffling footsteps throughout the crew quarters.

The history of the site of the park goes back even further, as the location of the quarantine station at Immigration Station No. 2. When Galveston was one of the largest ports of immigration to the United States, passengers who were ill were detained here until cleared to leave.

From 1906 to 1914, fifty thousand immigrants arrived in Galveston from Europe and Asia. Those who had contracted fatal diseases either before departure or on board never left Pelican Island and are sometimes seen pacing the shores of the small park during inclement weather.

THOMAS JEFFERSON LEAGUE BUILDING

2301–7 Strand

Built in 1840, the Moro Castle was the most popular public house and saloon in Galveston, luring customers in with a ten-pin alley, billiard tables and spirits of a different sort.

In 1869, the building was lost in a fire set to cover up a robbery at the nearby Cohn Brothers Clothing Store. The night it and the surrounding four blocks were burned to the ground was the same night the city's firemen's ball was being held. The men rushed to the emergency and valiantly fought the flames in costume and "full libation."

T.J. League, the son-in-law of Samuel May Williams, bought the burned-out property and built the present building in 1871, importing the ironwork arcade

The Thomas Jefferson League Building prior to restoration, 1970s. *Courtesy of Library of Congress, Prints & Photographs Division, HABS.*

and windows from New Orleans. It was the first of more than twenty buildings purchased and restored by George Mitchell in what was to become the Strand Historic District.

The apparition of a woman in white has been regularly seen since the building's restoration. Considered to be the socialite daughter of a prominent businessman of long ago, she played piano at the Moro despite her father's disapproval. When she fell in love with a worker at the bar, her family forbade them to marry.

Two security guards from the Tremont House were summoned to the building in 1998 to investigate complaints from hotel guests that someone was playing the piano there in the early morning hours. As they entered the banquet room, they saw a woman in Victorian dress sitting at the piano, playing.

Though they immediately left the premises that night, when they were called on to return at another time, they found the building empty.

Banquet employees have heard piano music drifting down from the third floor, and the spirit of the woman has been seen strolling in the open-air atrium. If she is looking for her lost love, she might hope that he, too, will follow the music.

BEACH GHOSTS

While mention of the beach usually brings thoughts of sunny days and fun afternoons, the gulf waters can just as easily bring danger and tragedy.

As you stroll along the beaches of Galveston, you'll never be entirely alone. If you look closely just at dusk, you might see any number of lost souls wandering the shore. There are reports of a weeping woman holding the hand of her child who walks along the beach and sometimes follows visitors, looking for a way home.

During the early days of the city before an inland cemetery was established, burials were conducted in the large sand dunes along the side of the island facing the Gulf of Mexico. The towering dunes, covered with grass and trees, were a simple solution for family and friends who were responsible for the interments of the departed before the age of the funeral business. In 1839 alone, 250 victims of a yellow fever epidemic were buried in the dunes along the beach.

But the nature of sand is to shift and change, and coffins or remains were regularly uncovered or washed out to sea.

After the 1900 storm, the beach witnessed burials in its dunes once again as the citizens, overwhelmed by the number of bodies, resorted to burying them wherever they were found. The victims of the orphanage were among those discovered in the sand.

One poor young man, I. Thompson, who was praised for his ongoing lifesaving efforts the night of the Great Storm, eventually went insane because of the terrible things he witnessed that night. He ran from his room at the Washington Hotel one night and drowned himself in the surf to quiet his tormenting visions.

The beach also served as a convenient place to dispose of murder victims, as any evidence of the culprit was likely to be washed away. Mrs. George Hopper in 1914, Webster Christian in 1917 and numerous men and women whose identities were never discovered have been found along the shore.

Bathhouse family portrait, 1911. *Author's collection.*

Many suicides have also occurred on the beach, just out of eyesight of the crowed bathhouses and restaurants.

Drowning victims and sailors washed overboard in the gulf also joined the all-too-often anonymous number of bodies found by someone taking a stroll by the warm waters.

Is it any wonder that the sands are so populated with ghosts?

NATIONAL HOTEL ARTIST LOFTS

2221 Market

Built in 1870, the building now known as the National Hotel Artist Lofts was once the Tremont Opera House. The wonderful carved Toujouse bar at the Tremont House originally served people in the basement here before and after they attended performances.

By 1895, the city had a new opera house, so this structure was reinvented as office and retail space, with a jewelry store on the ground floor. After surviving the 1900 storm, it had other incarnations as a bank and the National Hotel.

Former residents here have seen the shadowy figure of a man sporting large mutton-chop sideburns and dressed as a maintenance worker peering around doorways and walking up and down stairs. He sometimes begins to approach people just before fading away.

The front door of the former Tremont Opera House. *Author's collection.*

A small, sullen girl has also been seen wandering downstairs and was caught on security footage of the Slices bar when it was located there.

W.L. MOODY BUILDING

2202–6 Strand

Once a four-story building, this brick and terra-cotta beauty is a Nicholas Clayton design that lost its fourth-floor cornice-mounted clock and mansard roof during the 1900 storm.

In his memoirs, one gentleman from the Moody family remembered that the family could catch fish from the rear windows because it was waterfront

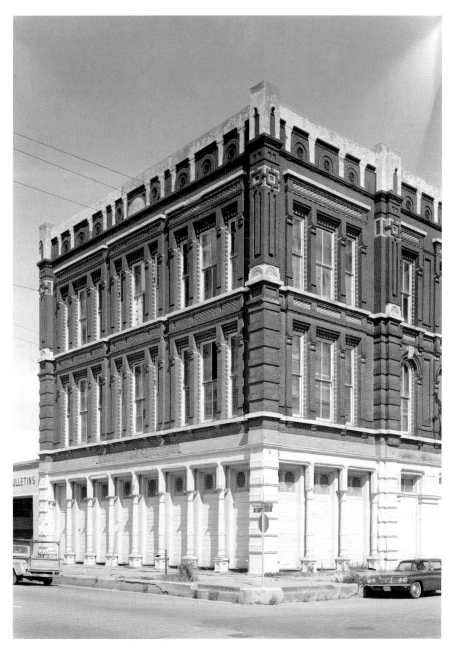

The W.L. Moody Building prior to restoration, 1970s. *Courtesy of Library of Congress, Prints & Photographs Division, HABS.*

at the time. In order to build so close to the water, an immense concrete foundation was created and sunk into the water as a base.

For over thirty-five years, this location was the home of the iconic Colonel Bubbie's Surplus Store on the Strand, attracting locals and tourists. The late owner of the establishment nicknamed the building's ghost Harold and told visitors that although the spirit was a bit mischievous, he was quite friendly.

Items were moved and rearranged on every floor, and footsteps could be heard between the aisles and overhead.

Although customers were often intrigued by the stories they had heard, the owners gently told visitors that the upper floors were off limits to the public due to the large amount of stacked inventory and the condition of the building. Anyone who had the chance to visit the crowded rows of military memorabilia on the first floor can attest to the overwhelming amount of stock available at the store.

Harold is patiently waiting for the building's next tenant.

HAWLEY HOUSE

2327 Avenue K

At one time known as the Virginia Point Inn, this Mediterranean-style home was erected by Waters S. Davis in the Silk Stocking Historic District in 1907 as a wedding present for Harry and Sarah Hawley. Though the original design was of simple wood construction, it was modified with stucco in 1923.

The home was used as a bed-and-breakfast in the 1980s, and guests regularly reported unusual occurrences, such as windows and closet doors opening and closing by themselves and ghostly footsteps in the hallway.

When one couple staying at the inn revealed that their ancestors apparently didn't get along with the Hawleys, two pictures from the wall abruptly crashed to the ground, expressing the spirits' displeasure at their presence.

A male guest was once woken up by a female voice calling for him to "come downstairs and visit with me awhile." From 2:00 to 4:00 a.m., the gentleman sat pleasantly conversing with a woman wearing an old-fashioned dress and finally excused himself to return to bed. When he mentioned it to the innkeeper at breakfast, he learned there had been no other guests in the house that night.

In the master bedroom, the rustling of someone walking in a dressing gown can be heard, and the rhythmic sound of a rocking chair emanates from a corner where Sarah's chair had once been.

AUGUST LANGE HOME

1329 Twenty-Fourth Street

Thomas Dinsdale designed this beautiful Queen Anne–style home, with its strikingly curved front window, in 1899. It was built for August Lange, who was a diamond setter for Fred Allen & Company Jewelers. He shared it with his wife, Martha, and their daughter, Bertha.

Later owned by George Hodson and his wife, Alice, the home became a gathering place for community events due to George's membership in the local Masonic Harmony Lodge and Alice's participation in church groups.

Of their two daughters, Rebecca and Dorothy, only the latter married. A schoolteacher, Rebecca remained in the home with her widower father. They both passed away in the house.

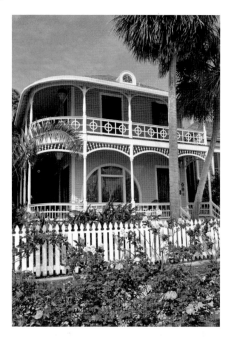

The home of August Lange. *Author's collection.*

Homeowners of the Lange House have been awoken at night by various sounds, including the tinkling of a bell inside a child's ball, bouncing down the stairs. A toy vacuum has been heard to switch itself on, as has a video recording device.

Once, a female resident saw the apparition of a light-haired boy, about twelve years old and dressed in Victorian-era clothes, standing in her master bedroom. After briefly making eye contact, he turned and disappeared into a sold wall. The boy has never been seen again.

At night, three voices have been heard conversing in normal tones, but not so loudly that their words can be discerned. The phenomenon has been witnessed by as many as three people at the same time. If the voices are asked to stop talking, the conversation immediately ceases. There is a lot to be said for considerate spirits.

About the Author

K athleen Shanahan Maca lives in Clear Lake, Texas, and works on Galveston Island, writing about its history.

A graduate of Sam Houston State University, she is the author of *Galveston's Broadway Cemeteries* from Arcadia Publishing and a member of the Texas Chapter of the Association for Gravestone Studies.

A fan of ghost stories and legends since she was a child, she uses her experience in historical research and genealogy to add dimension to local folklore.